I intend to stand firm and let the peacocks multiply, for I am sure that, in the end, the last word will be theirs.

—Flannery O'Connor, *The King of Birds*

Petah Coyne

Everything That Rises Must Converge

MASS MoCA North Adams

Yale University Press New Haven and London

Published on the occasion of *Petah Coyne: Everything That Rises Must Converge*, on view at MASS MoCA from May 29, 2010, through April 11, 2011.

The exhibition *Petah Coyne: Everything That Rises Must Converge* was made possible by the Toby D. Lewis Philanthropic Fund of the Jewish Community Federation of Cleveland, the Elizabeth A. Sackler Museum Educational Trust, Galerie Lelong, McBride & Associates Architects, and the Massachusetts Cultural Council. Additional support provided by Dennis Braddock and Janice Niemi, Carol and William Browne, Linda and Ronald F. Daitz, Pamela and Robert Goergen, Jane and Leonard Korman, Anita Laudone and Colin Harley, the Barbara Lee Family Foundation, Kari McCabe and Nate McBride, Kate and Hans Morris, Sam and Martha Peterson, Elizabeth Ryan, and Stone Ridge Orchard.

The title for this book and accompanying exhibition was inspired by Flannery O'Connor's short story and essay collection *Everything That Rises Must Converge* (New York: Farrar, Straus and Giroux, 1965).

Published by
Yale University Press
302 Temple Street
P.O. Box 209040
New Haven, Connecticut 06520-9040
www.yalebooks.com

in association with
MASS MoCA
1040 MASS MoCA Way
North Adams, Massachusetts 01247-2450
413.MoCA.111
www.massmoca.org

Design by Dan McKinley
Printed by GHP in Connecticut
ISBN: 978-0-300-16770-2
Number of illustrations: 65

Photo credits: p. 15: Erich Lessing/Art Resource, NY; pp. 24, 25, 26, 27, 28–29: D. James Dee; pp. 23, 30, 31, 32, 33, 34–35, 56, 57: Jean Vong; pp. 36–37, 50–51, 92–93, 94, 95: Art Evans; pp. 49, 54, 55, 59, 60, 61, 67, 68, 69, 70, 71, 72, 73, 74, 75, 76–77, 78, 79, 81, 82, 83, 85, 86, 87: Wit McKay; pp. 52: B. Orcott; p. 53: Tom Powell; pp. 62, 63, 65, 89, 90, 91: Elisabeth Bernstein

Cover image: *Untitled #1336 (Scalapino Nu Shu)*, 2009–10

Petah Coyne
Everything That Rises Must Converge
Table of Contents

Foreword

A world in which "everything that rises must converge" is a world of extraordinary physics indeed, countervailing in almost every way, and therefore a perfect title for this exhibition of Petah Coyne's extraordinary art.

In our world—clinging as we are to the fragile knap of the convex curvature of the earth—to rise upward is to diverge from every other particle also rising, to radiate outward from the core. Imagine wire spokes, driven into a rubber ball, each perfectly aligned to the center. As they emanate out and away from the ball, like discrete rays of light, their ends grow further and further apart. Only if we somehow magically inhabited the interior lining of a sphere could rising inward from its concave surface lead toward a convergent point of singularity, the core. And that would be a good description of the world wrought by Coyne, a world of dense, enfolding forces, a world in which rising from the surface takes one inwards to some dark, ultimate center.

During the installation of these works I remarked to Petah that the black velvets, black sand, the shredded and spun metals, and the deep burgundies of the wax and silk flowers would all soak up so much light that the museum would likely run out of wattage before they were fully illuminated, and she said, "Oh, yes, there can almost never be enough light for these works." If the works are insatiable of light, they are also nearly impossible to photograph (despite the always amazing work of Art Evans). I can only hope that if you're reading this catalogue, you also saw the exhibition, which is one of the most striking installations we've ever mounted at MASS MoCA.

This was not an easy show to execute. Petah's works are complex, delicate, and sensitive to movement, the materials demanding of care. We are therefore doubly indebted to Petah Coyne, both for the art itself, and for the many ways in which she and her excellent studio staff joined with my colleagues at the museum—most especially our curator Denise Markonish—to make this exhibition possible.

A presentation of this ambition also takes generous support from many, and in many forms, and we were lucky to enjoy it thanks to the Toby D. Lewis Philanthropic Fund of the Jewish Community Federation of Cleveland, the Elizabeth A. Sackler Museum Educational Trust, Galerie Lelong (especially Mary Sabbatino), McBride & Associates Architects, and the Massachusetts Cultural Council. Additional support provided by Dennis Braddock and Janice Niemi, Carol and William Browne, Linda and Ronald F. Daitz, Pamela and Robert Goergen, Jane and Leonard Korman, Anita Laudone and Colin Harley, the Barbara Lee Family Foundation, Kari McCabe and Nate McBride, Kate and Hans Morris, Sam and Martha Peterson, Elizabeth Ryan, and Stone Ridge Orchard.

—*Joseph C. Thompson, Director, MASS MoCA*

I was reminded how, as a child, I used to drop flowers into large bottles of ink. The flowers would float on the surface for a moment and then the stem would get swamped, and then the petals, and they would bloom with dark.

—Colum McCann, *Let the Great World Spin*

fade to black

by Denise Markonish

For the past two decades Petah Coyne's work has increasingly bloomed with dark. Though Coyne's practice has always dealt with somber undercurrents, this trait has become ever more prevalent as she shifted from working with the organic and ephemeral — such as straw, dead fish, and hair — to her current range of materials, like metal, black sand, wax, and taxidermy. What unites Coyne's oeuvre, however, is her consistent exploration of a kind of darkness, one full of opposing forces beyond merely black and white.

An ideal complement for Coyne exists in Southern Gothic writer Flannery O'Connor (1925–1964), whose work also blooms with dark. In her 1963 short story, "Everything That Rises Must Converge," O'Connor tells the story of Julian, an embarrassed and arrogant man riding a newly racially integrated bus with his blatantly bigoted mother. Tension grows as an African-American woman and her son board the bus. In the end Julian attempts to abandon his mother, but cannot bring himself to do so. This story implies human weakness, morality, and redemption. At one point Julian's mother, attempting to engage him in a debate about segregation, states that: "It's ridiculous. It's simply not realistic. They should rise, yes, but on their own side of the fence."[1] This phrase brings to light the idea of what it means to rise, and that no matter what side of the fence we are on we all rise, and in that act we inevitably converge. O'Connor's works are like morality plays, referencing religion but always abruptly taking foreboding turns, questioning the goodness in society. The title of O'Connor's story therefore becomes a perfect accompaniment to Coyne's work, which slips between innocence and seduction, life and death, vulnerability and aggression, all the while employing a baroque sense of beauty — an unusual beauty best summed up by philosopher Edmund Burke (1729–97), as follows: "Beauty in distress is much the most affecting beauty."[2] It is through this beauty wrought with distress that Coyne's work makes the journey from darkness to light.

1. Flannery O'Connor, "Everything That Rises Must Converge," *The Complete Stories* (New York: Farrar, Straus and Giroux, 1971), p. 408.

2. Edmund Burke, *A Philosophical Inquiry into the Origin of Our Ideas of the Sublime and the Beautiful* (London: Routledge and Kegan Paul, 1958), p. 110.

Denise Markonish is a curator at MASS MoCA.

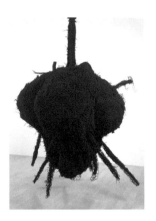

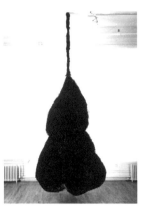

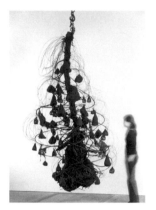

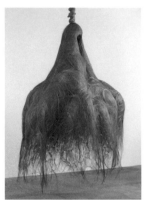

[FIG. 1]
Untitled #670 (Black Heart), 1990

[FIG. 2]
Untitled #672 (David), 1989–91

[FIG. 3]
Untitled #638 (Whirlwind), 1989

[FIG. 4]
Untitled #720 (Eguchi's Ghost),
1992/2007

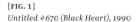

Burke countered his discussion of beauty with one of darkness. In Burke's definition of the sublime,[3] he inextricably links the phenomenon to fear, vastness, and the unknown. So one could say that the sublime ultimately draws its beauty from darkness. However, Burke rightfully points out that darkness and blackness, though related, are two different things. For Burke: "Blackness is but a *partial darkness*; and therefore it derives some of its powers from being mixed and surrounded with coloured bodies. In its own nature, it cannot be considered as a colour."[4] Dark, therefore, is a feeling verging on emotion, while black is but one vehicle towards this state of being. With Burke's clarification in mind, it becomes apparent just how Coyne's works, while rooted in the color black, descend (or bloom) with dark. Coyne's most pronounced use of black began in the late 1980s, when the artist discovered "black sand," a by-product of pig iron casting.[5] At the time, Coyne was looking for new materials that felt organic without seeming ephemeral. This desire for a tactile yet lasting medium resulted from a need to hold on to something solid after spending many years working with cancer patients. The black sand also reminded Coyne of Venice, and the dichotomy between the area's beauty and the industrial waste produced at Marghera and dumped into the waters surrounding the city. Out of this experience came a series of works where Coyne transformed black sand and metal into sculptures that are physically strong, yet still imbued with the vulnerabilities of the organic.

 Untitled #670 (Black Heart) (1990) [FIG. 1] and *Untitled #672 (David)* (1989–91) [FIG. 2] are two such works. *Black Heart* harkens back to Coyne's days working in the medical

3. Burke says of the sublime: "Whatever is fitted in any sort to excite the ideas of pain, and danger, that is to say, whatever is in any sort terrible, or is conversant about terrible objects, or operates in a manner analogous to terror, is a source of the sublime." *A Philosophical Inquiry*, p. 39.

4. Burke, p. 147.

5. Green sand is used in the process of casting pig iron (which is similar to cast iron), turning black upon contact with the molten metal.

industry and an opportunity she took to witness open-heart surgery. The experience immediately impressed upon Coyne the vulnerability of life, and she wanted to transform her feelings into an artwork that would verge on the awkward. As a result, *Black Heart* hangs from the ceiling as an almost amorphous lump, referencing the anatomical rather than anthropomorphic organ. The piece borders on being ugly, with wire spikes emerging from the form; however, at the same time the black sand glints on the surface, adding a sense of animation—bringing blackness to life. As a companion to this work, *David* similarly hangs from the ceiling, but hovers just above the floor. As free-floating as *Black Heart*, *David* is nevertheless grounded, a hulking mass of entwined fencing. The fencing counters the weight of the form, creating a lacy quality or airiness that further adds a surprising lightness to the sculpture. This balance between mass and air is made ever more palpable when one is told that the piece was made in memory of two departed friends of the artist. Unlike the subtle vulnerability evident in *Black Heart* and *David*, *Untitled #638 (Whirlwind)* (1989) [FIG. 3] has all the strength of a storm. In addition to being inspired by Venice, when Coyne walked to her studio across New York's Pulaski Bridge she looked at the factories lining the landscape, and became enthralled by their sense of perpetual motion. Coyne then linked these elements to dance and choreography. As a result, *Whirlwind* twists and turns before our eyes. The funnel-like form of the piece starts with a bell at the bottom and then rises up—almost like a tornado in reverse. Swirling around this central form is a series of smaller teardrop shapes and wire. These circling elements are like small galaxies or clouds orbiting the central core of the work. All of this movement, along with the effects of the light hitting the black sand, makes the piece virtually whirl before our eyes.

Coyne further explored this notion of movement by collaborating directly with the dance world. In *Untitled #720 (Eguchi's Ghost)* (1992/2007) [FIG. 4], Coyne combines mass with movement. The tile of the work refers to Old Eguchi, the protagonist of Japanese author Yasunari Kawabata's story "House of the Sleeping Beauties" (1961). In this story Eguchi

goes to the house of sleeping beauties, a place where men nearing death can spend the night sleeping next to young unconscious women. The story makes palpable the loneliness of beauty, but also how desire and death are inextricably linked. Throughout the narrative Eguchi is conflicted about his compulsion to sleep next to these women. Coyne's work imagines Eguchi as a silver ghost in the form of a massive cape with a dark void where his face would be. The piece, though hollow, immediately seems both inhabited and lurking. The material of the piece comes as the biggest surprise—what appears at first to be hair or fiber is actually a shredded aluminum airstream trailer. The transformation of industrial material to the organic is startling, an effect made even more palpable when Coyne arranged for the piece to be "performed." In this dance, a large man put on *Eguchi's Ghost* while carrying atop his shoulders a small Japanese woman, resulting in a kind of hybrid figure with a man's legs and woman's face. Here, as in Kawabata's story, the sleeping figures merged, creating a new ghost made up of death and innocence.

Movement is also a key element in Coyne's photography, which is in essence about capturing the fleeting moments of life. When Coyne takes her photographs, often with customized cameras, both she and her subjects are in motion—quite like a dance—leading to a sense of transitory presence. Like her sculptures, Coyne's photographs are imbued with often-indefinable narratives, which haunt her images like ghosts. Coyne's photographs verge on the abstract, from *Untitled #885 (Saucer Baby)* (1997) [FIG. 5], an image of a child in an inner-tube being twirled across a pool that is part alien, part celebration of playful exuberance, to the *Bridal Series*, depicting unfocused pleats and folds of wedding dresses that at once seem to be embodied and empty. For example, in *Untitled #1043 (Full Frame Skirt)* (2001) [FIG. 6], we get the sense that a bride is running, her feet invisible in the motion of the billowing white material rushing towards the left of the frame. Is this a moment of joy or has she just fled the altar? It is impossible to tell. A similar urgency is evident in *Untitled #735 (Monks II)* (1992) [FIG. 7], a huddled mass of robed Japanese monks running through the forest. The figures are surrounded by

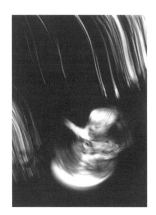

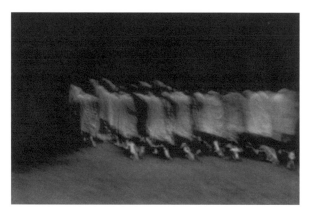

[FIG. 5]
Untitled #885 (Saucer Baby, Carolyn Rose Series), 1997

[FIG. 6]
Untitled #1043 (Full Frame Skirt, Bridal Series), 2001

[FIG. 7]
Untitled #735 (Monks II, Monk Series), 1992

darkness and become a representation of togetherness, a singular gesture of movement. There is a sense of unease about this picture, which is counter to the stereotypical image of the serene seated monk. By showing their movement, Coyne, in a way, confirms the humanity in the divine—the body in the ghost.

Given Coyne's penchant for dichotomous elements and religious subtexts, her work fits perfectly within ideas of the Baroque. The Baroque of the sixteenth to eighteenth centuries originally rose out of the Catholic Church's response to the Protestant Reformation. The Church sought to support art that would communicate religious themes through emotion. Therefore, this era moved from Classicism's intellectual perfection to a type of art that was more visceral and aimed at the senses. Particularly present at this time were sculptures that showed the movement and energy of the human form, most evident in the *Ecstasy of Saint Theresa* (1647–52) [FIG 8.] by Gian Lorenzo Bernini (1598–1680) at the Cornaro Chapel

of the Church of Santa Maria della Vittoria in Rome. Bernini's sculpture embodies sexuality as Saint Theresa writhes, rapt with religious ecstasy. However, what is increasingly evident in this composition is the complexity and stylized decadence of Saint Theresa's robes, a trait that would become the hallmark of the Baroque—detail that goes beyond the norm. French theoretician Gilles Deleuze (1925–95) picked up on this idea of "the fold" and used it to define the essence of the Baroque. The fold for Deleuze, much like the sublime for Burke, is embodied by infinity. The fold collapses in on itself and then unravels, revealing layers of meaning and reference. In speaking of still life painting, Deleuze stated that: "The painting is so packed with folds that there results a sort of schizophrenic 'stuffing.' They could not be unraveled without going to infinity and thus extracting its spiritual lesson."[6]

6. Gilles Deleuze, *The Fold: Leibniz and the Baroque*, trans. Tom Conley (Minneapolis: University of Minnesota Press, 1993), p. 123.

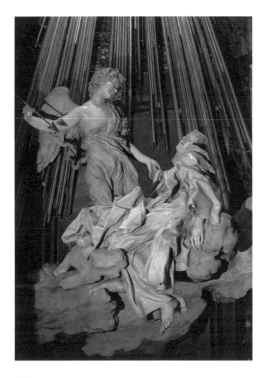

[FIG. 8]
Gian Lorenzo Bernini (1598-1680), *Ecstacy of Saint Theresa of Avila*, 1647–52. Marble. Cornaro Chapel

The fold is an ever-present element in Coyne's more recent work using silk flowers dipped in wax, velvet, and taxidermy. *Untitled #1240 (Black Cloud)* (2007–08) [FIG. 9] is an orgy of decadence. A riot of ducks is diving and rising up from a mass of wax-coated flowers, surrounded by folds of black velvet. This work immediately recalls W. S. Merwin's poem *Birds Waking* (1958), which contains the lines: "Increasing still as the birds themselves rose/From the black trees and whirled in

a rising cloud...Louder and louder singing, shrieking, laughing..."[7] The birds in Coyne's work do form a black cloud, but from within this mass color is unfurled, both in the iridescent blues and greens natural to the birds' plumage and the deep jewel tones of the blue, purple, and red flowers, which subtly break through their black wax shell. Signaling this attempt to rise from blackness is one bird, which hangs above the sculpture almost beckoning the others to join it in flight.

The fold as a concept brings forth elements, revealing them by unraveling. However, the fold can just as easily collapse back in on itself in order to hide meaning. In *Untitled #1234 (Tom's Twin)* (2007–08) [FIG. 10], the central element of the work takes the form of a large mound of flowers on the floor, recalling a burial. In all of Coyne's works the use of flowers and wax cannot help but reference the decay associated with death and funerary practices. This subtext is even more palpable as hidden amidst the folds of the sculpture is a small crib. In fact, when looking at the work, the floor mound subtly turns into the figure of a woman lying on her side, and contained within that gesture, within the fold, is a sense of sadness and loss. Though Coyne's Baroque borrows from the folds of Deleuze, when fully considering works like *Black Cloud* or *Tom's Twin* an equally apt definition can be found in the words of Mexican poet and writer Octavio Paz (1914–98), who described the movement as follows: "The Baroque is solid and complete; at the same time, it is fluid and fleeting. It congeals into a form that an instant later dissolves into a cloud. It is a sculpture that is a pyre, a pyre that is a heap of ashes. Epitaph of the flame, cradle of the phoenix."[8] Both of these works come from the ashes of experience and strive to rise again, just like the phoenix.

In addition to personal reference material, Coyne is also inspired by film and literature; yet no matter what her source may be, she consistently invents her own brand of interpretation through this lens of Baroque refinement. Starting in 1997, Coyne began work on a series of sculptures inspired by the epic poem *The Divine Comedy* (1308–21) by Dante Alighieri

7. W. S. Merwin, "Birds Waking," *Green With Beasts* (New York: Knopf, 1956).

8. Octavio Paz, "The Will for Form," *Mexico: Splendors of Thirty Centuries* (New York: The Metropolitan Museum of Art, 1990), pp. 24–28.

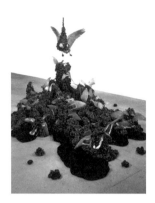

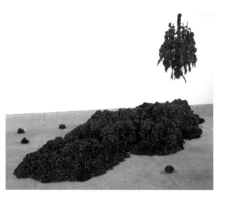

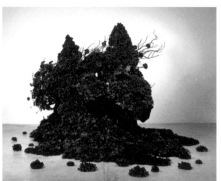

[FIG. 9]
Untitled #1240 (Black Cloud),
2007–08

[FIG. 10]
Untitled #1234 (Tom's Twin), 2007–08

[FIG. 11]
Untitled #1205 (Virgil), 1997–2008

(1265–1321). This poem, broken down into three parts, traces Dante's journey from hell to purgatory and finally to heaven. Speaking of the Baroque, writer Umberto Eco said that the period is "[S]o to speak, beyond good and evil…[allowing] Beauty to be expressed through ugliness, truth through falsehood, and life through death."[9] This same sentiment is evident in Coyne's interpretation of Dante's text and its characters. The first of Dante's characters presented by Coyne is *Untitled #1205 (Virgil)* (1997–2008) [FIG. 11]. Virgil, best known as a Roman poet of the first century BC, serves as Dante's guide through *The Inferno* and *Purgatorio.* Canto I of *The Inferno* begins with the phrase: "Midway on our life's journey, I found myself/In dark woods, the right road lost. To tell/About those woods is hard—so tangled and rough"[10] In Coyne's work, Virgil becomes the woods themselves. This deep black

sculpture, with hints of dark reds and purples, appears before viewers like a tangled tree, with branches emerging from the top of the work. Tucked within the mass are a taxidermy bobcat and game bird, the first referencing Virgil, while the second stands in for Dante. The two creatures share space but are never quite together, referencing the difficult journey ahead through the underworld. In another work, *Untitled #1281 (Canto VIII)* (2008) [FIG. 12] , Coyne references a passage in which Dante and Virgil reach the fifth circle of hell, reserved for fraud. The canto begins with the demon Phlegyas steering a boat across the River Styx. When Dante climbs aboard the boat it begins to sink, making evident Dante's status as a mortal. In Coyne's piece, a bird trapped in flowers still appears to be soaring, signaling the flight from the underworld back to the mortal realm.

The centerpiece of Coyne's Dante series is *Untitled #1180 (Beatrice)* (2003–08) [FIG. 13]. Standing over eleven feet tall, *Beatrice* is a true beauty who radiates energy, color, and motion, much as the actual Beatrice did for Dante. Beatrice

9. *History of Beauty*, ed. Umberto Eco (New York: Rizzoli, 2004), p. 233.

10. Dante Alighieri, *The Inferno*, trans. Robert Pinsky (New York: Farrar, Straus and Giroux, 1996), Canto I, lines 1–3.

Portinari (1266–1291) was a Florentine woman who inspired Dante's *La Vita Nuova* (1295) and also served as his guide through paradise in *The Divine Comedy*. Though it was said that they met but a few times, she enchanted Dante, who stated: "She came clad in vermillion, the noblest color, modest and virtuous; girdled and adorned in harmony with her tender years. In that moment I must truly say that the vital spark, which abides in the most secret chamber of my heart, set to trembling with such violence that even the slightest beat of my heart seemed horribly strong, as trembling, it uttered these words "ecce dues fortior me, qui veniens dominabitur mihi." (Behold a god stronger than I, and he shall come to rule over me.)"[11] Coyne's embodiment of Beatrice depicts her as a towering woman made of birds and flowers — she seems unattainable, beyond the reach of the viewer, just as she was beyond the reach of Dante. What continually remains remarkable about Coyne's work is how she animates the inanimate. Though her birds are taxidermy and her flowers both silk and encased in wax, all of these elements burst with life, beckoning us to follow them into an enchanted fairy-tale realm.

Beatrice, with her sense of transformation, becomes a harbinger of light breaking through into Coyne's work. Coyne's most recent sculpture blends all of these previous elements, retaining darkness moving to light, all the while referencing sources from Flannery O'Connor to the Baroque and beyond. *Untitled #1336 (Scalapino Nu Shu)* (2009–10) [FIG. 14] is visually startling. Coyne took a fourteen-foot-tall craggy apple tree that was about to be cut down and gave it a new life through its own death. Coyne cut down the tree, removed its bark, and returned once again to the use of black sand by covering the entire tree in the material, until the wood began to take on the look of soft shimmering velvet. This alone would be a wondrous sight, but Coyne goes further by populating the tree with taxidermy birds; hanging down from the branches are seventeen pheasants, and perched above them are ten peacocks.

Peacocks were of particular interest to O'Connor, who wrote about and lovingly raised these birds. It was natural for O'Connor to feel an affinity for the peacock, as it serves as a symbol of renewal and transformation, as well as being seen as the "eyes" of the Catholic Church, elements that were often woven through her narratives. In her story, "The Displaced Person" (1954), the peacock serves as a metaphor for both pride and power. The narrative follows Mrs. McIntyre who is trying to run a farm and hires a displaced WWII-era Polish emigrant named Guizac. At first there is suspicion surrounding Guizac's arrival, but soon his hardworking nature leads Mrs. McIntyre to reconsider her work force. In the end, Guizac is killed after accidentally being run over by a tractor, which leaves him splayed out on the ground in a crucifixion pose. Peacocks feature prominently in this story as both objects of wonder and nuisance. O'Connor writes: "He had jumped into the tree and his tail hung in front of her, full of fierce planets with eyes that were each ringed in green and set against a sun that was gold in one second's light and salmon-colored in the next. She might have been looking at a map of the universe but she didn't notice it any more than she did the spots of sky that cracked the dull green of the tree."[12] The peacock signals a shift from the earthly to spiritual realm; while on the ground it is a pest ruining plants; however, once in the trees it becomes god-like.

The peacocks hanging from Coyne's tree are brilliant, with their iridescent feathers set off against the blackness of the tree. However, what is unusual about these birds is that rather than fanning their tails and exhibiting their pride, they seem to be almost frozen, waiting in time. The pheasants hanging down further emphasize the feeling that some event is in the process of happening. However, unlike the peacocks, the pheasants appear to be dead, hanging by their feet, heads down. This blend of beauty and potential fear is embodied for Coyne in the story of Nu Shu.[13] Literally meaning "women's

11. Dante Alighieri, "La Vita Nuova," *History of Beauty*, p. 171.

12. Flannery O'Connor, "The Displaced Person," *The Complete Stories*, p. 200.

13. For an in-depth discussion of Nu Shu, see Lisa See's novel, *Snow Flower and the Secret Fan* (New York: Random House, 2009).

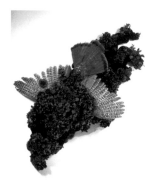

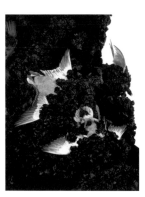

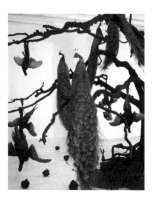

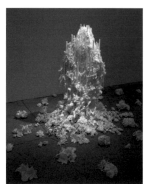

[FIG. 12]
Untitled #1281 (Canto VIII), 2008

[FIG. 13]
detail: *Untitled #1180 (Beatrice)*,
2003–08

[FIG. 14]
Untitled # 1336 (Scalapino Nu Shu),
2009–10

[FIG. 15]
Untitled #1093 (Buddha Boy),
2001–03

writing," Nu Shu is a centuries-old technique used among women in Jiangyong County in the Hunan province of southern China. The writing resembles a more slender and stylized form of Chinese and was used to express feelings of loneliness and fear in an era of arranged marriages and foot-binding. Nu Shu is thought to be the world's only gender-specific language and was written in letters, embroidered, and sung. Coyne was particularly taken by the story of Nu Shu and the connections it created between women who were separated in a male-dominated society. Over their lifetimes, Chinese women would form special bonds and write back and forth to each other; in death these writings were burned, resulting in very few examples of this script remaining today. It is almost as if in Coyne's tree a life cycle plays out from waiting to death, from enchanted to sinister — it too is a story told in secret writing to a most intimate friend. Through Nu Shu, Coyne further makes

reference to her own kind of sworn sisterhood, embodied by her friendship with poet Leslie Scalapino, for whom the piece is also named.

Just as with the *Ecstasy of Saint Theresa*, light appears for Coyne in the most unlikely of places. Amidst all the dark in Coyne's work, a sense of joy comes through in *Untitled #1093 (Buddha Boy)* (2001–03) [FIG. 15]. *Buddha Boy* looks like a convergence between religious statuary and a candle-strewn altarpiece grown wild. Small in terms of Coyne's work, the sculpture stands only fifty-two inches tall, requiring viewers to bend their knees to come face to face with the form. Once this genuflection is complete, a female face emerges from the sculpture — counter to the title of the work — made of dripping white wax, pearls, and flowers. It borders on a religious experience to kneel before this piece, resulting in an overwhelming sense of release or calm. All of Coyne's works are full

of surprises, of darkness rising out of beauty, but in *Buddha Boy* the reverse is true. Coyne made this work just after September 11, 2001, when she was struck by an overwhelming sense of guilt. Seeing people fleeing the twin towers covered in white ash, Coyne immediately recalled the black rain that fell upon Hiroshima as a result of the atomic bomb. Now both countries would be forever marked. However, Coyne was also amazed at the kind of temporary paradise that could arise from such a hellish experience, the camaraderie of New York City, and the hundreds of personal shrines that crowded its streets. It is from this place that *Buddha Boy* beckons us down, to get on the same level with one another and acknowledge vulnerability.

Charles Baudelaire said: "Beauty is always bizarre. I don't mean to say that it is deliberately, coldly bizarre, for in that case it would be a monster that has gone off the rails of life. I say that it always contains a hint of the bizarre, which makes it beauty in particular." [14] Petah Coyne's work never goes off the rails, though it does veer towards the edges, hinting at the monstrous while always coming back to the dichotomous nature of beauty itself. In her work, influences from the Baroque to the sublime converge and rise from darkness to light before always fading back to black. These works are a feast for the eyes and riddles for the mind. As Albert Einstein said: "The most beautiful thing we can experience is the mysterious. It is the source of all true art and all science. He to whom this emotion is a stranger, who can no longer pause to wonder and stand rapt in awe, is as good as dead: his eyes are closed." Coyne's works keep our eyes open in a perpetual state of wonder and rapture — and in their presence we too can feel that we are able to fly like birds.

14. Charles Baudelaire, "On the Modern Idea of Progress Applied to the Fine Art" (1868), *History of Beauty*, p. 331.

The sky was dotted with fixed tranquil eyes like the spread tail of some celestial night bird.

—Flannery O'Connor, *The Violent Bear it Away*

Untitled #1018 (One Foot with Hem, The Debs Series), 2001

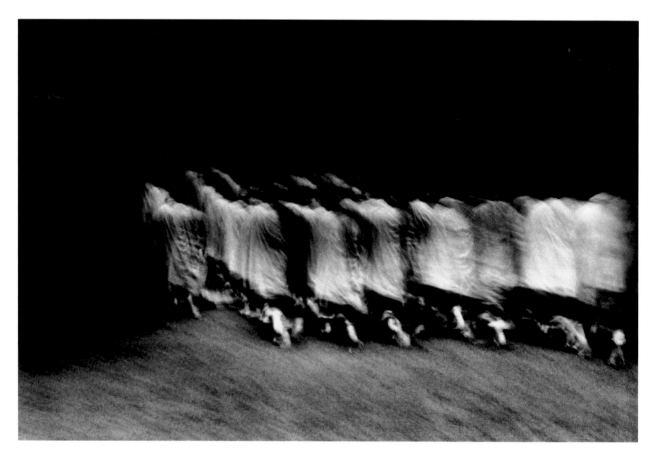

Untitled #735 (Monks II, Monk Series), 1992

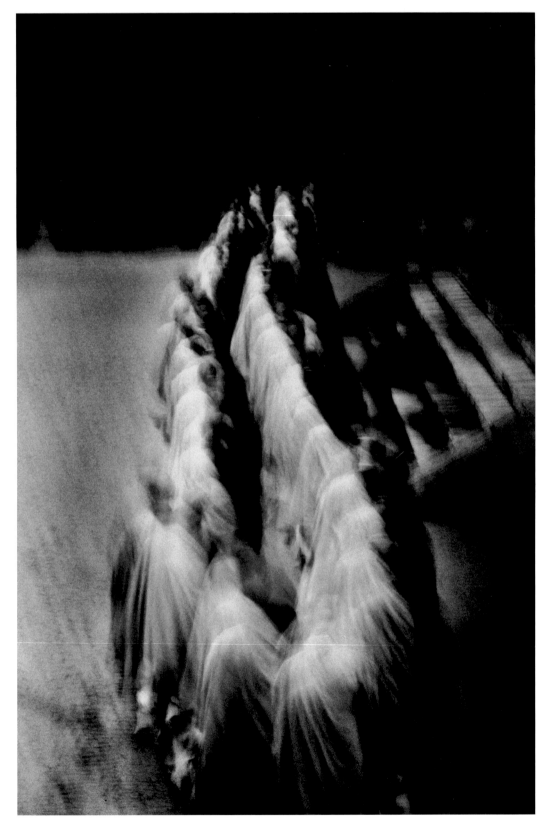

Untitled #883 (Tear Drop Monks, Monk Series), 1997

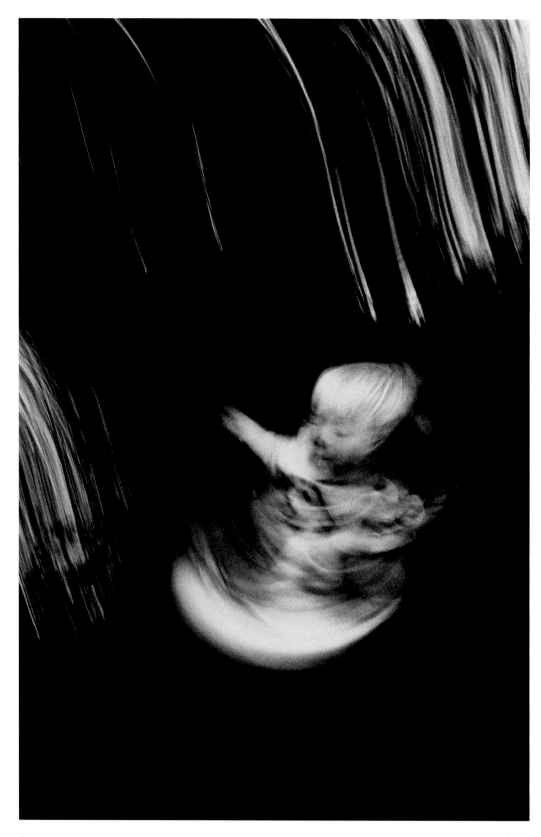

Untitled #885 (Saucer Baby, Carolyn Rose Series), 1997

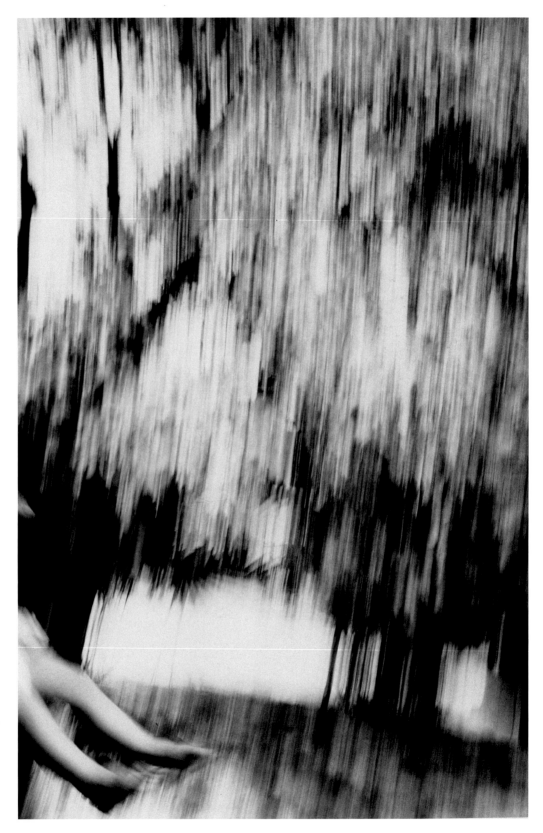

Untitled #901 (Legs, Carolyn Rose Series), 1997

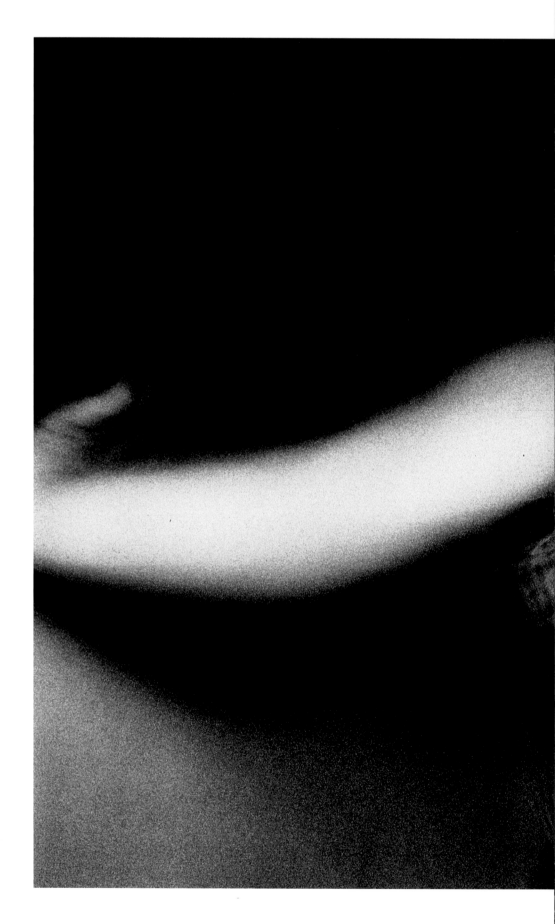

Untitled #844 (Haley,
Haley & Degas Series), 1996

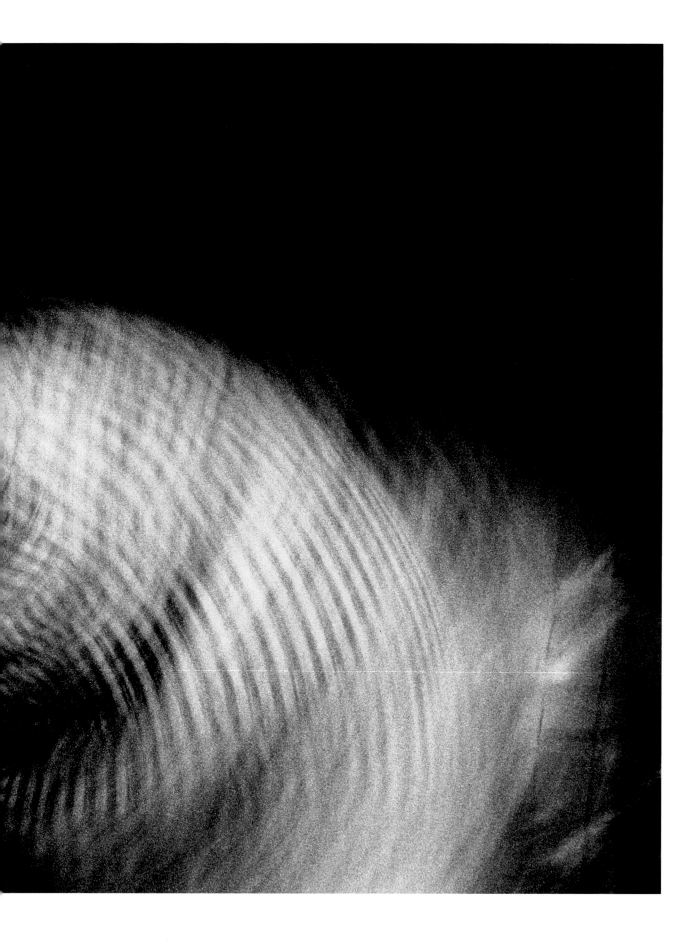

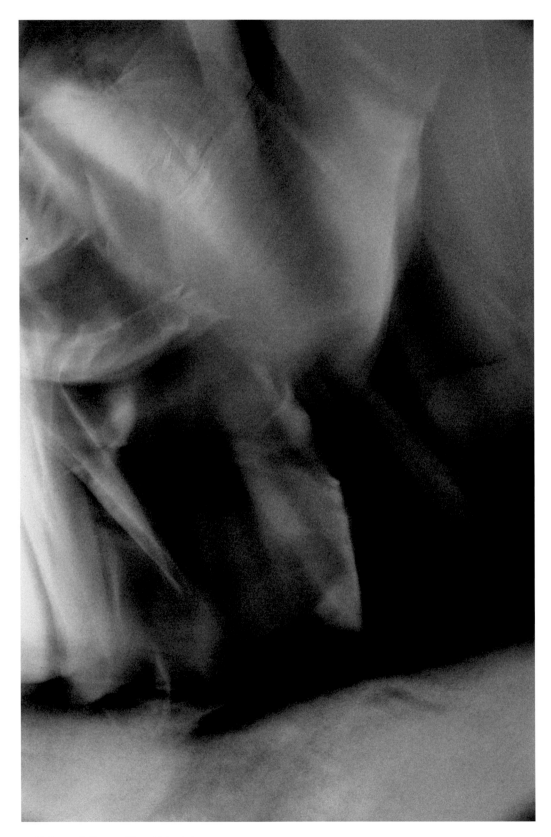

Untitled #1043 (Full Frame Skirt, Bridal Series), 2001

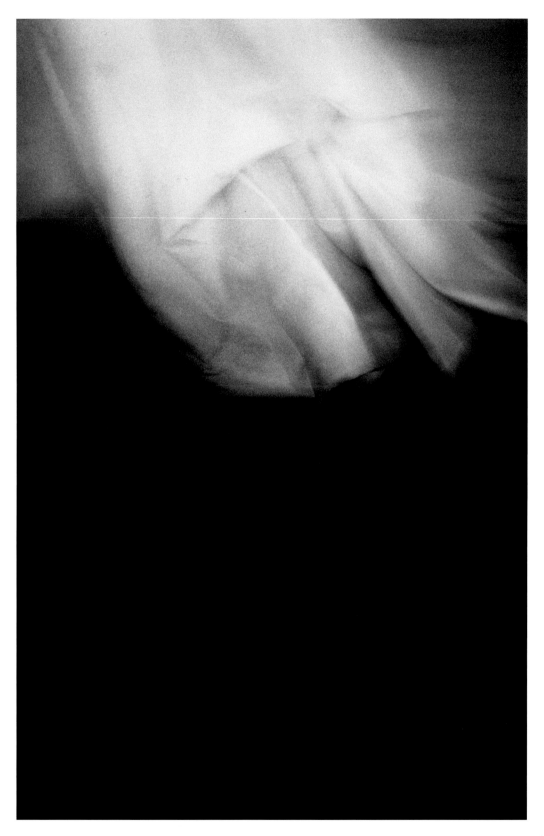

Untitled #1007 (Susan's Hem I, Bridal Series), 2001

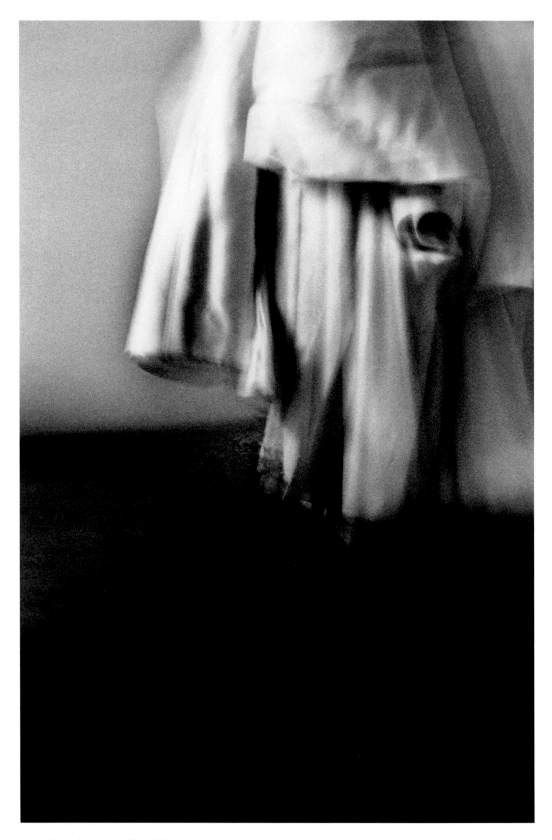

Untitled #1036 (Velazquez Bride, Bridal Series), 2001

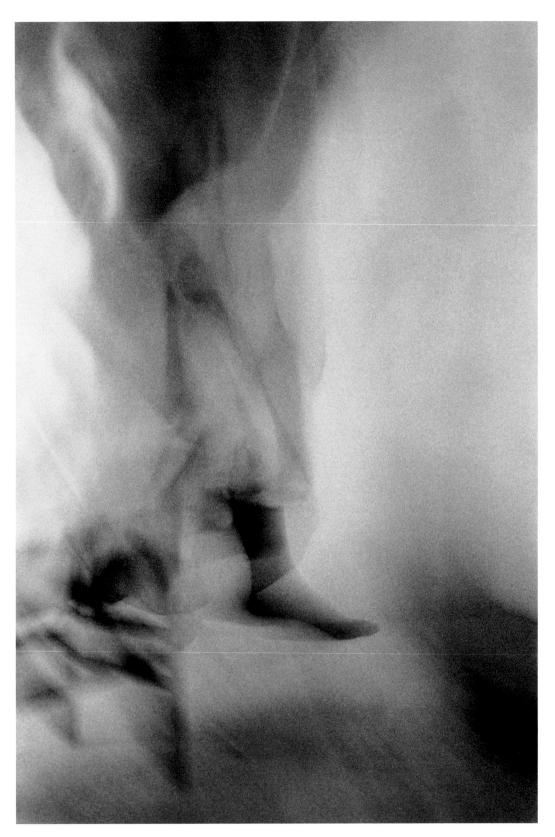

Untitled #1040 (One Leg Hanging, Bridal Series), 2001

Untitled #1017 (Raphaelite Feet Dancing, The Debs Series), 2001

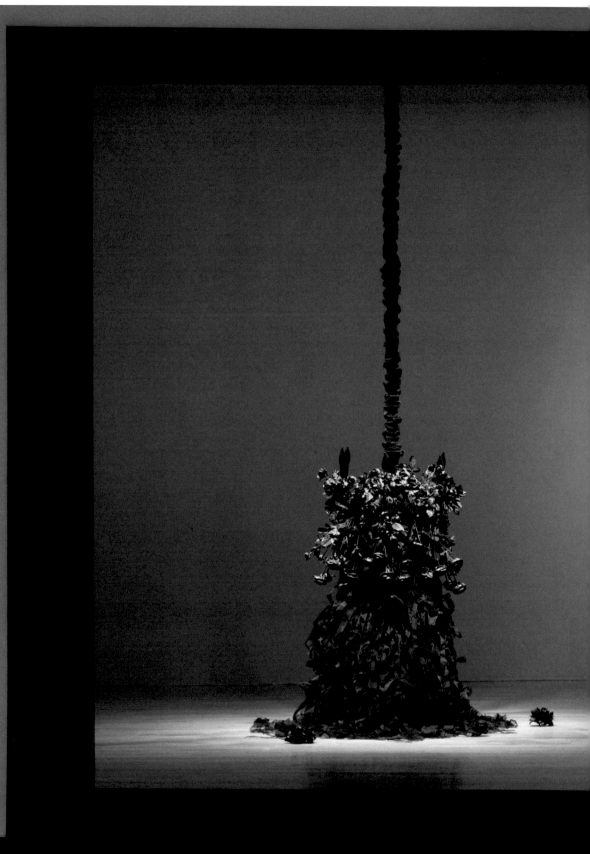

INSTALLATION VIEW
MASS MoCA, North Adams, 2010–11

LEFT
Untitled #1274 (Death in Venice),
2003–08

RIGHT
*Untitled #809 (Sun Rising,
Piñata Series)*, 1994

Black is boundless, the imagination races in the dark. Vivid dreams careening through the night. Goya's bats with goblin faces chuckle in the dark.

— Derek Jarman, "Black Arts"

40

Interview

Petah Coyne & Rebecca Solnit

San Francisco-based writer, activist, and historian Rebecca Solnit is the author of a dozen books, a contributing editor of Harper's, a frequent contributor to the political-essay site Tomdispatch.com, a reader, a walker, and a close observer of clouds, light, weather, slow social changes, sudden insurrections, grounds for hope, popular power, and imaginative spaces.

Rebecca Solnit: Looking at images of your work earlier today, I was thinking about how you choose the level at which the work takes place. Do you ever wish that the work could function in a more direct way, deal with politics and the surface and specific things of everyday life?

Petah Coyne: I don't think as an artist you ever choose what your vision is. I wish you could. I would be a minimalist.

RS: Because it's so tidy and convenient?

PC: Very tidy. And I would have other people make my work. I would sit in a very clean, nice house somewhere and look out on the ocean and have someone else make it.

RS: Phoning it in?

PC: Yes, phoning it in! It would be so lovely. I honestly don't think any of us are ever satisfied or would choose the art we make. It just comes to us.

There are many different levels where people can approach my work. They can look at it just at its first layer, where I try to make it very seductive. A lot of people take it just at that layer. And that's fine, but there are also all these other, different layers, layers of things that are buried in it. Most people never even get that far, but you can go as far as you want within it.

RS: There are other levels at which your work speaks to the politics of our time and to the things we don't think about: embodiment and decay and materiality and the strange states of American abundance and deprivation; to the life of the senses that underlies some of the things that a lot of us are thinking about the most right now. You think about something like climate change, and it's about heat and consumption and this deep underground wealth that's being extracted, this black stuff, burning everywhere on earth, and consequent melting and rising temperature. You can understand it on a level that's much more sensuous and embodied.

PC: One of the pieces that's in the show is actually a 1950s — oh, I forgot the name of it — a 1950s, those beautiful Airstream ...

RS: An Airstream trailer?

PC: Yes! Airstream trailer. It's called *Eguchi's Ghost*, named after a man in a beautiful Japanese tale. And what I did was all about recycling, and about the horrors of recycling. Everyone thinks recycling is a wonderful thing, and recycling is a wonderful thing, but nobody really follows the whole path of recycling. There's this amazing recycling plant right near Yale University where they take old cars, freight engines, and they shred it to nothing. They drop the remainders down three-story chutes, and they send it through machines that would scare the living daylights out of you. It's so big and so scary, but so powerful and wonderful in a horrifying way. Then they have these people they call "pickers" who take all the "fluff" out, like the car seats and the leather. The shredded metal ends up coming out as gold-colored wire, no matter the color of the car! And then they have giant mashers, which just slam into this shredded gold wire. They package it up, put it on boats. They used to send it to Japan, but now they send it to China. In China, they melt it back down and send it back to us to make the cars. And *that's* recycling!

But when they do all this, they're putting this horrible stuff into the atmosphere. At the time, I was totally enamored with all this material, so I bought a lot of it. And I paid to have this Airstream trailer smashed and shredded, but I halted the process. I didn't want to put anything toxic back into the air. Instead, I made this beautiful ghost of what it was. People can look at it as just this beautiful ghost, or they can look at it more deeply to investigate what it actually was at one time.

I did a performance with the piece. This ex-priest worked for me with his boyfriend. The boyfriend weighed 250 pounds, and he was beautiful. And he got in the "ghost" and then I had this very delicate Japanese woman sit on his shoulders and appear in the "ghost's" head. Sometimes her face would come out, sometimes it would recede, but his massive legs would be at the bottom of the piece. I thought: how wonderful to be there

and not be there, very similar to what was happening with the cars that had become the piece. Sort of like what was occurring and not occurring. But people don't think of that. They just think, "Oh, I'm being a very good person, I'm recycling." But what is the end result of all this recycling? So you see, the piece has all these levels, but I don't make it obvious. People have to do the research.

We're making a special room for the sculpture at MASS MoCA: it's an almost brown-black room so that the "ghost" stands out. The sculpture looks silver, because it's stainless steel. I put a little bit of phosphorus wire in it so it's luminous too. There's a beauty to it — I want there to be a beauty to it — but a horror also.

RS: My friend Chip Ward says that maybe we should throw out the word *environmentalist*. Because we now recognize that everything is implicated, everything is at stake, everything is the environment, and that we should just call it embodiment. It's interesting to even hear you talk about this place near Yale. Because one of the curious things about our age is how disembodied we are. We in the United States don't make much anymore. The job of both artists and environmentalists over the past few decades has been to put people back in touch with the processes of making, whether it's the illicit business of sweatshops or the kind of very sensuous, symbolic acts of making that artists engage in. So it's interesting to see a crossover where you're going to this dark, satanic mill of unmaking cars so they can be remade again. The way you describe it also sounds so Buddhist. Like it's kind of the formlessness, rather than the form of metal. The stages that they have to go into before they go back into being something familiar, recognizable, and usable. The dismembered phase of reincarnation.

PC: It's true, it's true. And yet, that process! In some ways the process was actually more fascinating to me than either end. At the plant, the smoke would fly out of the top of the chimney. It was like a cartoon. And, yet, you could step back and see the power of it. They had mountains of things, mountains of stuff that they pulled out. And you could think, "Whoa. I'm not sure

I need to make anything, it's so great here." I would love to just walk around, but, unfortunately, because you can so easily get hurt there, they don't really allow you to wander freely, though occasionally I could talk them into letting me into that yard. I think it's amazing.

RS: Wow. So it's still there?

PC: It's still there. They have one in New Jersey also. You can see it from the highway.

RS: It makes me think a little bit of Richard Misrach's pictures of dead animals in that livestock dump, and Edward Burtynsky's photographs of tires, quarries and refineries, and Chinese manufacturing plants. This sort of abundance, these heaps of matter that remain invisible, from which our familiar visible lives are extracted.

PC: Yes! Exactly.

RS: And one of the things that is so fascinating about your work and your fascination with heaps is that sense of formlessness and the kind of unmade. Even though you make the work with enormous craft and detail and attention, there is still enthusiasm for the non-being, the formless and the unmade, these other stages of being or un-being.

PC: Yes. There is something important to me about gathering it all and then just allowing it to be. I gather it with precision and then I just allow it to be what it needs to be.

RS: Do you think gathering is one of the fundamental acts of the work?

PC: I think so. It's been really interesting the last two weeks because this tree, which is part of the new work for this exhibition, was so complicated to coat. I thought it was really interesting that we had to dig up the tree. It was going to be destroyed because it was forty years old and no longer producing much fruit. Elizabeth Ryan, the owner of Stone Ridge Orchard, let us choose this tree from a big orchard of a hundred. We dug it up and took all the bark off it — which was a huge job — and put it in the kilns to dry and then brought it to the studio. I always knew I wanted to cover it in black sand, but I never knew the extent of detail that it would take to put the sand on the tree so perfectly. We had to do it quickly, because all the other processes took much longer than I had predicted. At the last moment I had to call in all my old assistants, some of them from twenty years ago. I probably had ten or twelve people a day coming in. You can't imagine the *detail* that it took to get this sand so perfectly black on the tree! But now it looks so magnificent. It's otherworldly; the black is so dense. It looks beyond burnt, it looks scalded or something. I can't even describe the surface to you. There's a disturbing darkness to it that I've never seen before. And when the peacocks are on the tree, it's shockingly beautiful, but a disturbing kind of beauty that I can't really quite understand yet.

RS: The tree was a fruit tree?

PC: It was an apple tree. There were a hundred trees to choose from, but this was the craggiest, most Japanese-looking one. And everyone else who was there looking with us was saying, "That's the ugliest one here!" And I was amazed because that's why I loved it so much. It was exquisite.

RS: Taking in the orphans?

PC: Yes, I guess so! It just had such a look about it that was so unique and different from every single angle. And it's big! It's twenty-two, twenty-three feet in every direction, and it's fourteen feet tall. It's big. It feels a lot bigger when you're throwing black sand on it [*laughs*].

RS: The pictures that you sent me with the peacocks are tremendous. Where do the peacocks come from, literally and imaginatively?

PC: The peacocks have all these references of immortality and regeneration. I don't know if you read that biography of Flannery O'Connor by Brad Gooch that came out last summer? It's absolutely excellent, and it made me reread all her books again.

In it he mentions … or maybe I reread it in her diaries… that a peacock represents the eyes of the Catholic Church. I thought, oh how perfect to have all of these peacocks sitting in this tree at this particular time, especially when the whole world is watching the Catholic Church.

The Catholic Church is under more pressure now than it's ever been. It's really at a crossroads. They can either become really great, or the Church will fall to pieces. I think they have to make some big decisions, and it'll be very, very interesting to see what they do.

And maybe, in the end, it will be a very positive thing for women within the Catholic Church. So… I don't know. But the peacocks are certainly waiting. The tree has a lot of references to waiting in it, too. It's called *Scalapino Nu Shu*.

Leslie Scalapino is a very good friend of mine. We often write back and forth; she'll send me poems and I'll do pieces, or she'll send me parts of poems and we'll go back and forth like that. Nu Shu is a private writing, a secret writing between women in China. It was done when they were children. They were taught this secret language, and they often had one particular friend to whom they wrote throughout their lives. When one or the other died, all their letters were buried or were burned and buried with them. Very few of these letters survived. As Leslie and I get older, all the peacocks are waiting for us.

RS: It's interesting to think about the eyes and the Church. Child molestation itself is about not seeing yourself; that kind of dividing and compartmentalizing of self, and then we find that the whole Church hierarchy refused to see too. This kind of blindness that makes the peacock blink.

PC: I never thought of that! Huh!

RS: And Argus, Hera's watchman, hundred-eyed Argus who gets turned into a peacock…The goddess Hera rewarded Argus for his service *after* he was slain, by placing his hundred eyes on the tail of her sacred bird, the peacock.

PC: Oh how wonderful! That's so incredible!

RS: Back to the idea of making … we don't actually make much anymore. And when we do, it feels surprising that people are still digging coal, that they're still mining gold, although I've been to the gold-mining belt of Nevada, and it's very disembodied. It's done by giant machines.

PC: What was it like?

RS: You know, it's kind of shocking. The price of gold is so high that it's affordable to use these giant earth movers where the tires are twice your height and they carry some insane amount, like forty tons at a time. And they're digging below the water table, so they're pumping out the water. Essentially what they do is grind up the soil and pulverize rock. Whole mountains are being turned into dust. And then they run a cyanide solution through it, and the cyanide attaches to the gold and pulls it out of the mix. What you are left with are toxic pools of cyanide, as well as all the other heavy metals that have leeched out. When I first heard about this in the beginning of the 1990s, I was told that there were lakes of cyanide and that they hired men to row across them, firing air guns at the birds to keep them from landing. Cyanide at least breaks down when exposed to sunlight; the lakes don't last forever, but the heavy metals do. And they've pumped out a lot of the water table that's the source for these springs and wells in the deep desert, ground up these mountains, released all these toxins, so that people can have, you know, high school rings and earrings, gold jewelry and stuff. But the proportions, it's like two thousand tons to an ounce of gold, or something like that.

PC: I was just going to ask you!

RS: And there's this amazing Western Shoshone elder, Carrie Dann, I worked with a lot in the early 1990s, whose own family graveyard was threatened by these mines, as well as sacred springs and geothermal sites, and the whole landscape is

essentially sacred to them. Although *sacred* is kind of a crummy word to describe the relationships. She said anyone who buys gold jewelry should get all the tailings that go with it. And I've always — it's what I said about environmentalists having that job of making the world visible. But unfortunately no one has ever said, "Your wedding bands weigh half an ounce, we're putting a thousand tons on your front lawn."

PC: That would be very powerful, wouldn't it?

RS: Yeah. You know where cars go when they die; I know where gold comes from.

PC: It's very ironic that they're peeling away the landscape to build a new mountain range of debris. When I was in the recycling centers in New Jersey and Connecticut there were *mountains* of stuff; everywhere you walked you would see huge piles of junk, hubcaps, engines, everything. I couldn't see anything, and I felt like I was wandering in the Rocky Mountains of man-made debris.

RS: Part of what is really interesting to me about your work isn't just the difference between additive and subtractive sculpture, but the engagement with what I think of as unmaking, with melting, decaying, and entropy and chaos. I read that cliché somewhere recently about the sculptor who sees the human form inside the block of marble, that Michelangelo cliché. And what's interesting is that it feels almost like you have an opposite vision, where you see the entropic process within the discrete, defined object — the systems of dissolution and metamorphosis, this material that's not static, but in slow motion. It's not moving in the gallery but it's melted, it's decayed, it's grown, something's happened to it, there's this kind of openness. A lot of your making sculpture is as much unmaking as making; does that make sense?

PC: I do think that's true, and it's a very unconscious process. I read a tremendous amount, as you know, and I do all my thinking, all my looking, outside the studio. When I go into the studio I try to erase all of that and go in there as purely as I possibly can, with nothing. I allow whatever is to be. What I try to do is use, from the most elemental standpoint, what is in front

of me. I try to do that most honestly and with everything that I've been thinking, everything I've been doing outside the studio — I let that just be so close to what is there, with the things I've gathered around me. And if I can be completely honest and open, it really seems to come together. And that's the real secret. If you don't try to force your real conscious mind on it, if you try to inflict things upon it, it becomes very self-conscious really quickly. It's like the best and the most pure.

RS: So it's about paring away not material, but imposed ideas and irrelevancies, to arrive at a pure understanding? That cliché that I am referencing, the Michelangelo trope, is about revealing, but in your work there's a kind of concealing or burying of things under other materials, of concealments, of revelations, of things lying in wait in your work, all these organic processes of melting, accreting, mutating. There's a kind of Ovid's *Metamorphoses* of materials that presents itself in your work over the years that's really interesting. An unseen world of roots, interiors, and darkness.

PC: I think that Michelangelo looked and saw what was inside. When I look, although I see what he sees, I don't build the way he builds. He took away, but I add. This dichotomy between adding and subtracting reminded me of all those years that I looked at surgery. I was involved in actually looking as they would open people up and take out tumors. This informed my thinking. You would think the body would be full of darkness, but it was so pink inside. And even though they were removing something that was supposed to be horrid, was supposed to be poisoning the body, it was a beautiful shape, a beautiful object. And although my work is made by adding to it — and I think this is what you are getting at — I apply the wax, apply all the bows, apply all the birds, and all the ribbons, then I pour the wax on and then I burn it off, so there is always this additive reduction; I put it on to keep it off. This is what the process is finally in the end. I make and take apart these pieces at least seven times. What's left is the residue of the piece. And then that becomes the piece.

RS: One of my favorite allegories for so many things is Penelope in the *Odyssey* weaving her bridal vestment by day, while the suitors hang out waiting for her to choose one of them to

marry, and she waits for her long-absent husband Odysseus to return. And she unweaves it by night, so, you know, she's a maker and an unmaker and these are both kind of her craft and her gift. This puts her in a kind of stasis, but engaging in the processes of ... you know, *unmaking* is the word that keeps coming to me. Making by unmaking. But surgeons, I think of them as sculptors who reshape but never really thought of them as subtractive sculptors, taking things away, taking things apart, opening them up.

PC: When you take something out, the body naturally fills up with water where whatever's been taken; it immediately fills up with water.

RS: Like a landscape. Like the holes the miners dig that are below the water table, these clawed-out caverns that become lakes.

PC: One of the first surgeries that I saw was where a bomb had gone off in someone's face. It had blown off half this man's face, which they reconstructed over a six-month period. The surgeons were so incredibly talented; they redid his eyebrows by taking skin from the back of this man's head, where his hairline was, to reconstruct the eyebrow and the eyelashes, so that this man would again have a complete, natural, matching other half of his face. I was so impressed. It was sculpture. It changed my whole idea of everything. And it was so amazing to me how they pulled the skin down ... it may sound very ghoulish, but to me, as an artist, it is something you have to see, and it's something that really informed me as a human. It makes me realize how vulnerable we are, how close to death and fragile we all are, psychologically, physically, and in every aspect. And it only makes me more tender toward other people.

RS: Surgery also really fascinates me — these medical procedures where in some ways you are damaging the body to save it. They are taking a knife to your flesh, but they are doing it so that you can live. Remind me how you ended up witnessing all these surgeries long ago?

PC: It all began when I came to New York. I wasn't feeling anything with the artwork I was seeing. The Neo-Geo thing was happening, and although I was intellectually challenged, I wasn't emotionally engaged with the art world. I would go in the galleries and think, "This is so cold." And I wanted to really feel something.

RS: [*laughs*] Is there anything more antithetical to Neo-Geo than surgery?

PC: [*laughs*] I wasn't being fed by the art world. I wanted to study further, so I began to work with these physicians who didn't really have the time to deal with patients who were dying of cancer. I began to do volunteer work; I was working for Chanel as a graphic designer during the week, and then I would work on the weekends for these doctors and I would just listen. That was my job, just to listen to the patients. They couldn't really talk to their families, they knew they were dying, they had a certain amount of time left to live, and they just needed someone to talk to. I could always tell right before they were going to die. There were all these signals, and they would usually tell me really important things right before the end. Some of them opted for surgery to remove their tumors, and I got to witness a lot of that surgery. And I used to think that those who would opt for surgery really wanted to live, that they would get the tumors out and survive. But sometimes when the tumors came out the people would go into mourning. It was a piece of them that had been taken out, it was too much for them. It was just so sad. It was a part of them that they had lost. And even though it was a poisonous part, they couldn't bear to lose it. It was fascinating, but really hard to bear; I only did it for three years.

RS: Three years, that's a long time.
 What's also so interesting is that a lot of sculptors, you and Kiki Smith, Ann Hamilton, a lot of young female sculptors, particularly in the past twenty or thirty years — you can go further back, too, to Eva Hesse — your sense, their sense of the body isn't of this neat, discrete, solid object that we get from art history's marble forms; it's an open import-export system of orifices, fluids, dissolution, and generation; it is a more female body where fluids are more present, where orifices are more present, or at least less repressed and denied; it's about the interpenetrability of self and world. The work re-imagines

embodiment as this perilous, vital, interpenetrated, alive system, part of a rethinking of the self in relation to the world…

This reminds me of the gold mining again and these heaps…another way to think about it is that sculpture has always been the gold, but you, and a lot of other sculptors, are actually making the sculpture that is the slag heap — what's left behind rather than the precious extract. We are not just connected to the gold ring; we're connected to the two thousand tons of ore that the gold came from, and maybe that is the sculpture, maybe that's what we should be thinking about and paying attention to. I feel something of that in your work, in a way, not that it's the leftovers, but that it's looking at what's left aside, what came before, what comes after, what's buried, what's secret, what comes out of and goes into the dark.

PC: Oh, I definitely think so, and it makes me realize I have to be stronger about it.

Sometimes I feel overworked, but I know it's a privilege to be a sculptor working today. There is a lot of intense labor, but it is labor for my art. That's an enormous difference. A hundred and fifty years ago it was impossible, unheard of, for a woman to be a sculptor. There were some painters, but very few sculptors. So the territory is wide open for my generation. There is much to discover. The complexities of feelings, emotions, and experiences are hard to express verbally. It's an exciting time, a potent time and a really difficult time, but I'm thrilled to be a part of it.

I thought I could be gentler and people would investigate the work more and eventually get to the point, but I can see that there is too much in the world, that people are too busy to investigate everything, so I have to be stronger. I have to be more forceful about my point in order to make them investigate it. Now I have to figure that out, I have to figure out a way for them to *need* to investigate it. I want them to realize there is more. That's what I want. I always feel like I haven't gone far enough, you know.

RS: In your daydreams on the ferry to the studio, if the other passengers heard you, what would happen, what would they hear?

PC: [*laughs*] I guess I would be going over the lists in my head: checking more résumés, organizing the packing of crates, going over shipping manifests and packing lists.

RS: [*laughs*] But what about the revolution?

PC: You and I would be complaining longer…thank you for reminding me, Rebecca! I will remember that forever.

Untitled #638 (Whirlwind), 1989

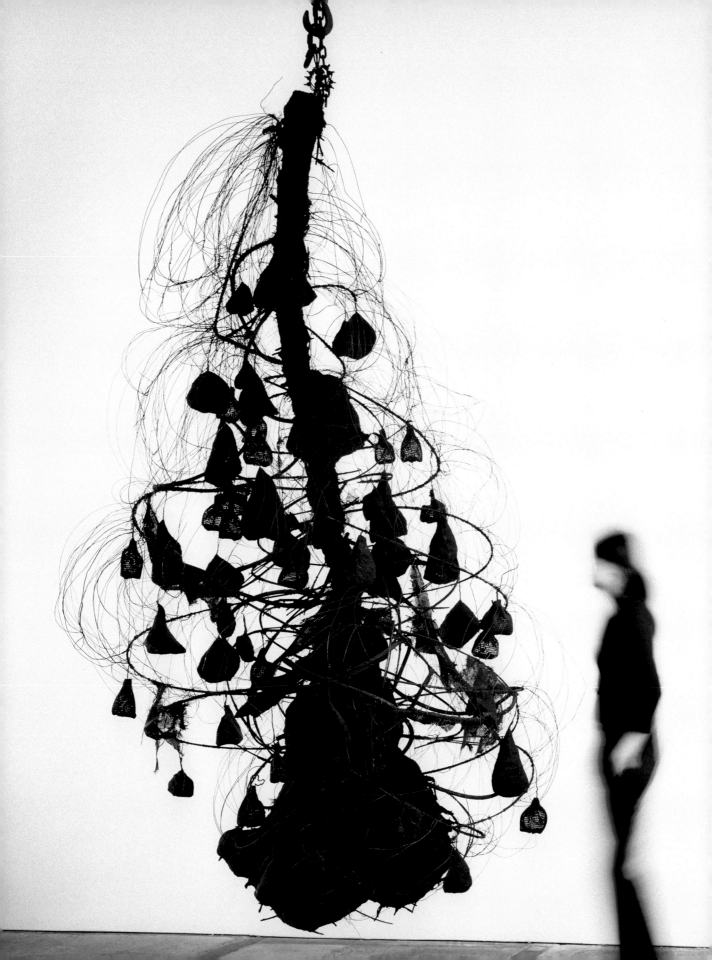

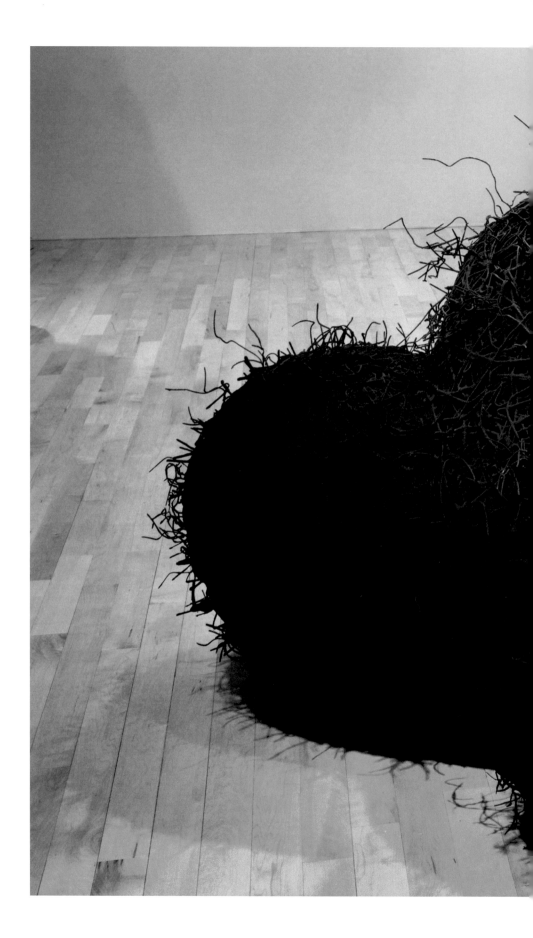

Untitled #669 (Fallen), 1990–91

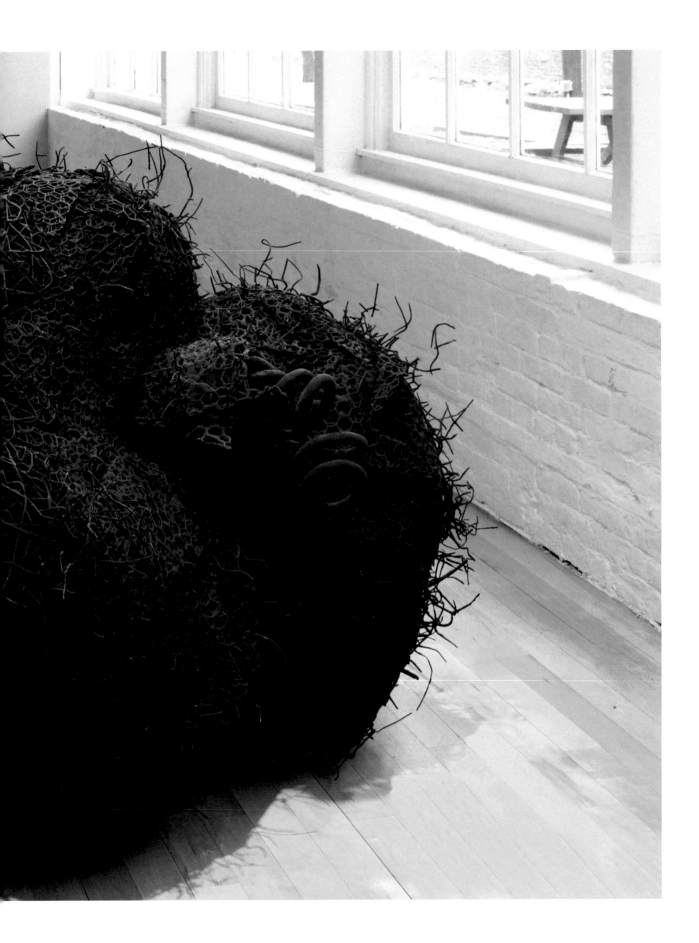

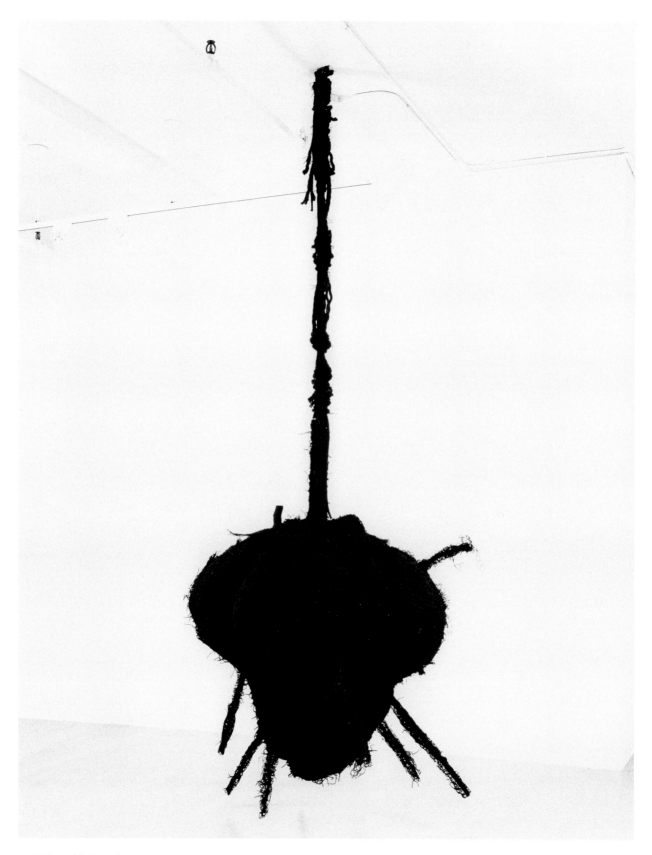

Untitled #670 (Black Heart), 1990

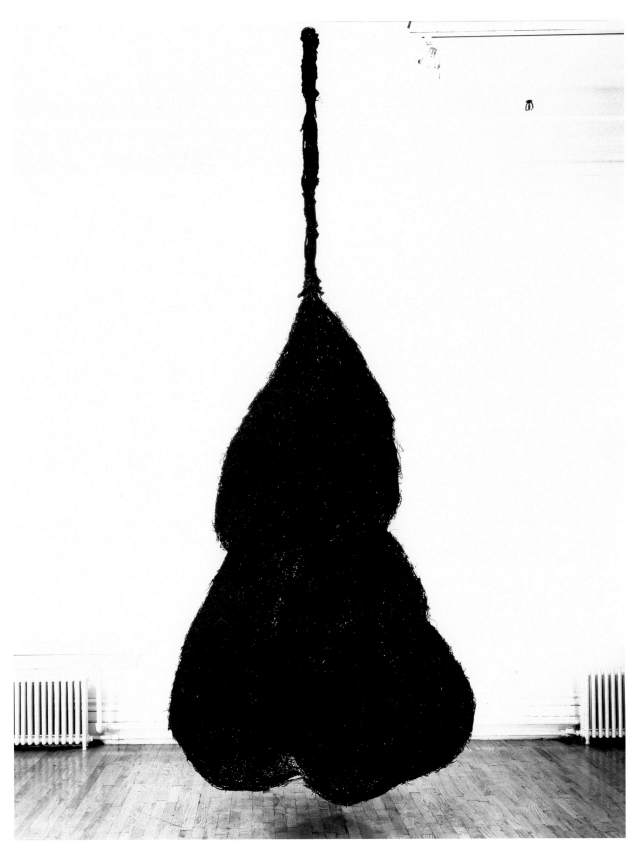

Untitled #672 (David), 1989–91

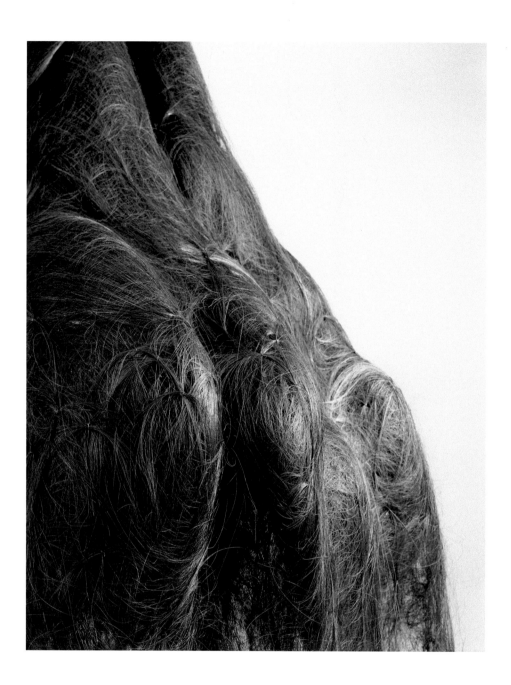

Untitled #720 (Eguchi's Ghost), 1992/2007

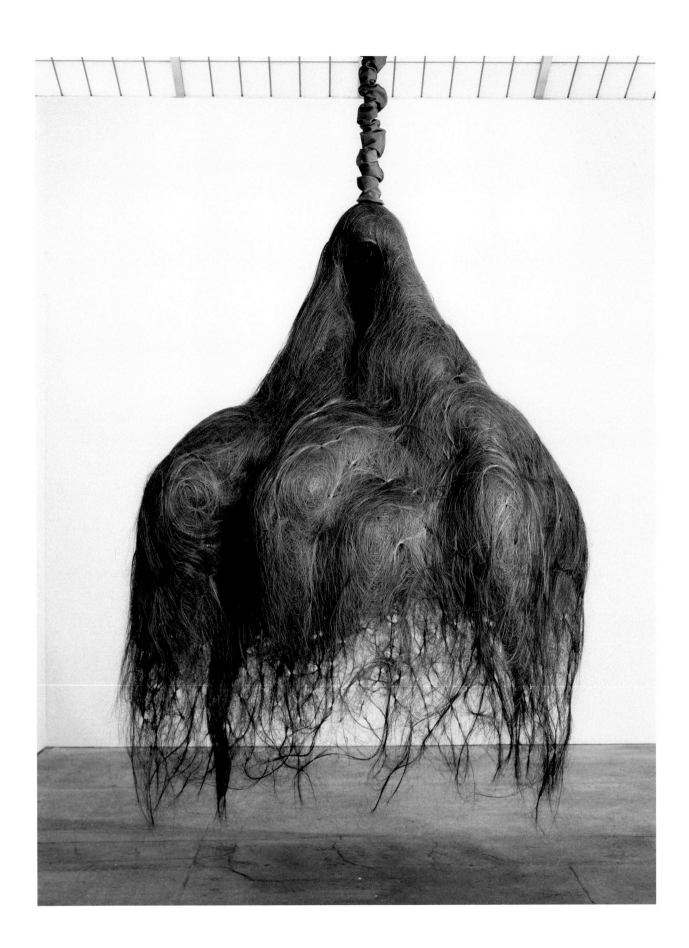

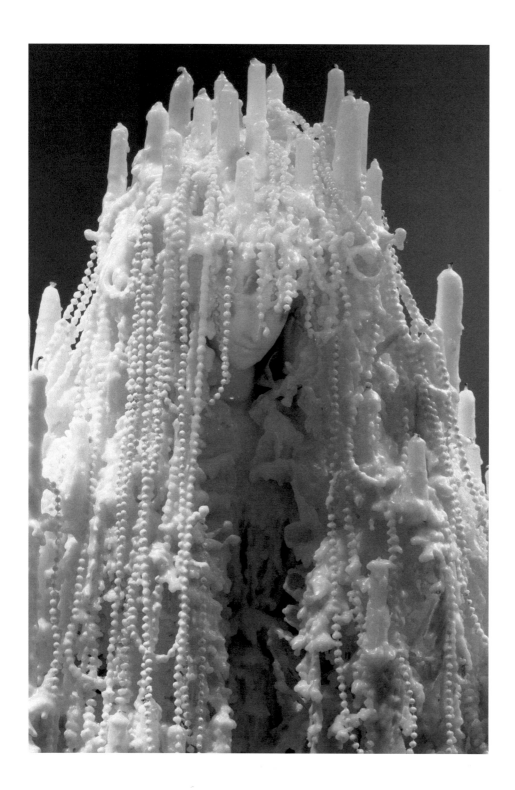

Untitled #1093 (Buddha Boy), 2001–03

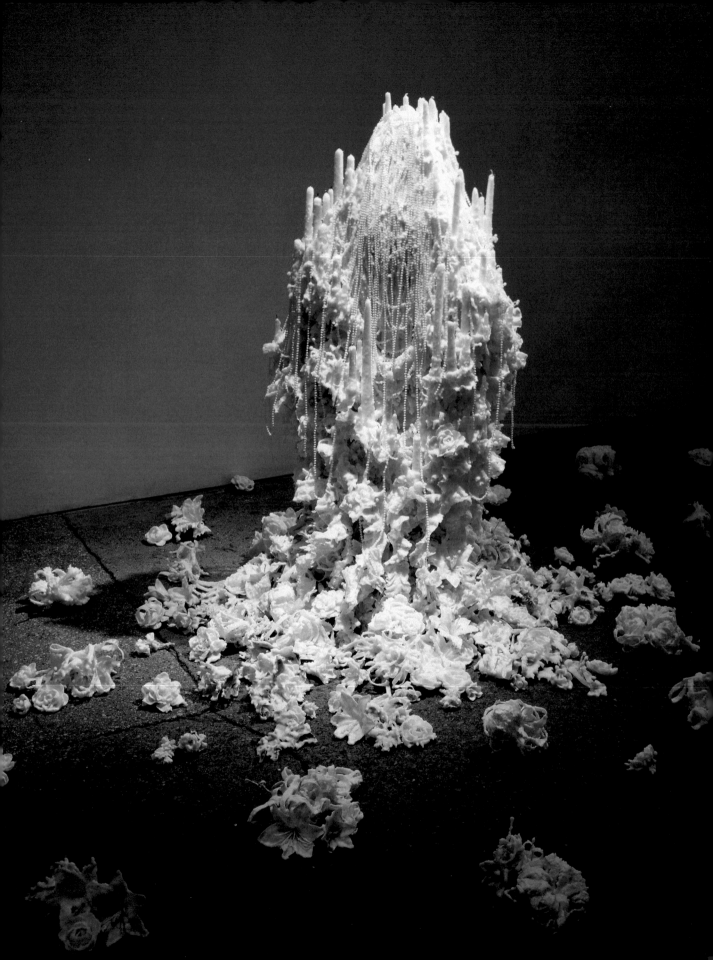

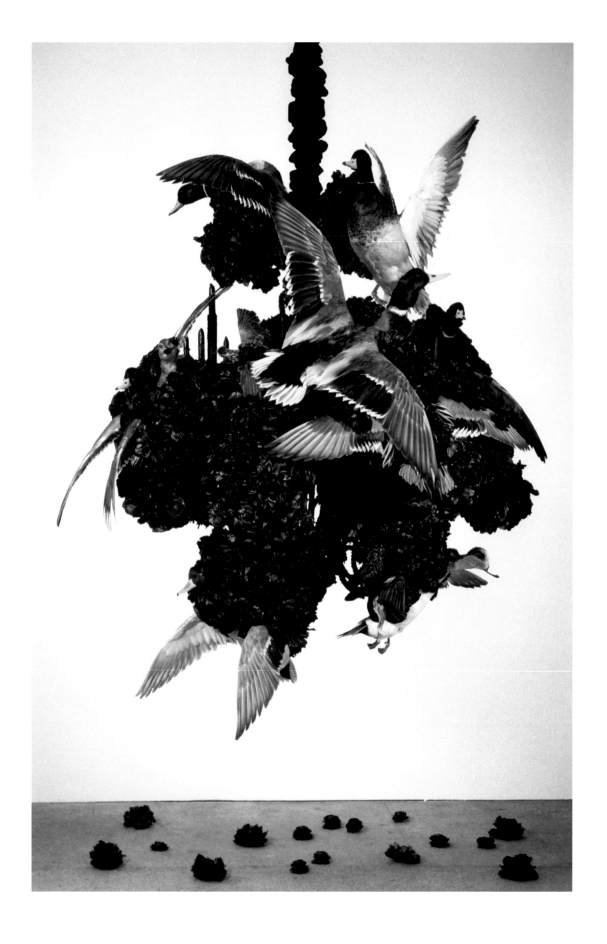

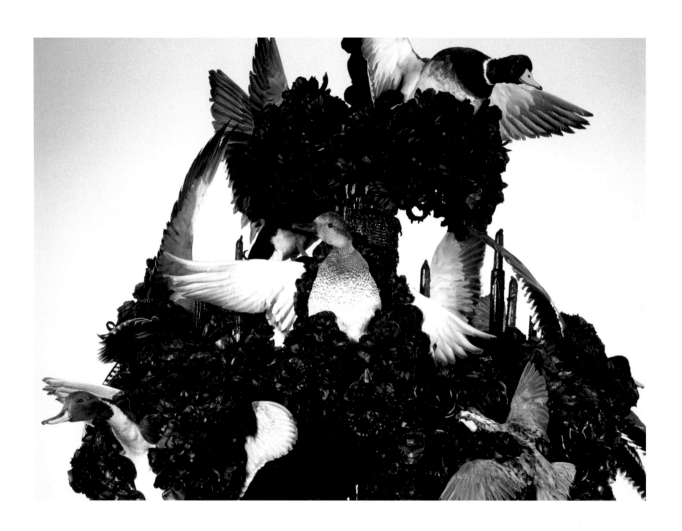

DETAILS
Untitled #1175 (La Notte), 2003–08

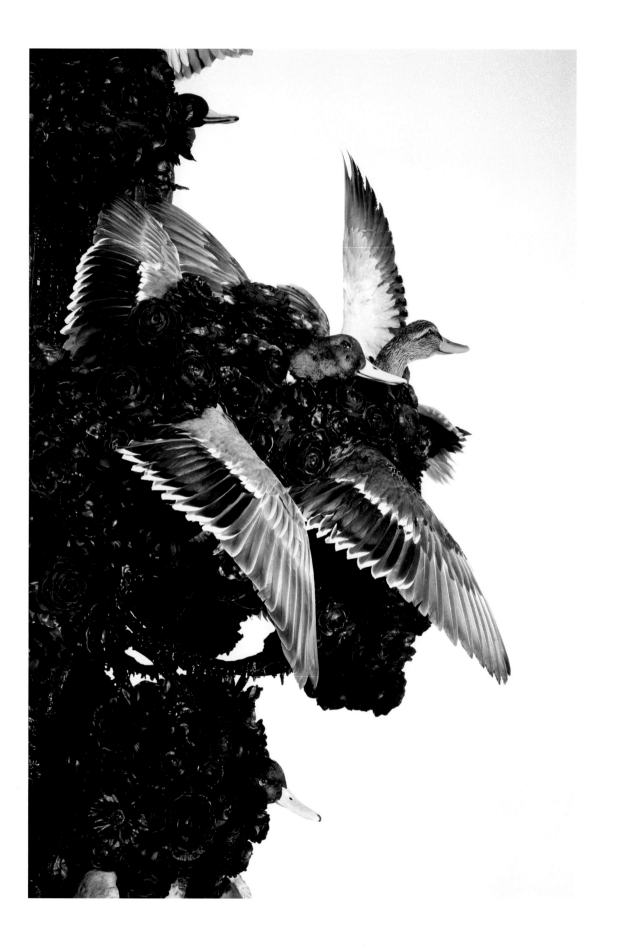

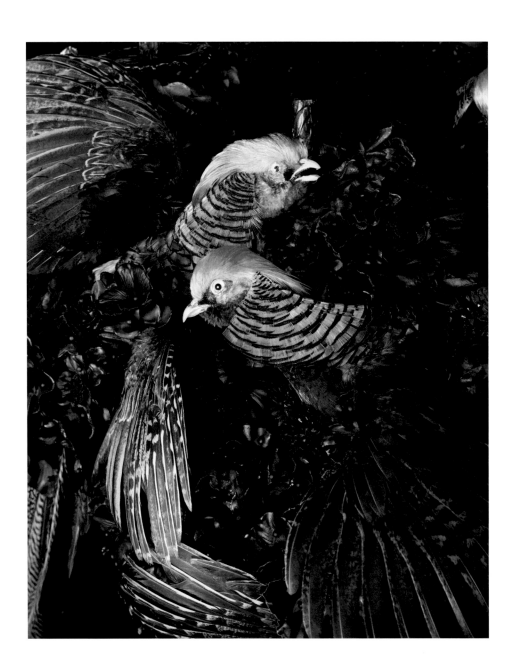

Untitled #1176 (Elisabeth-Elizabeth), 2007–10

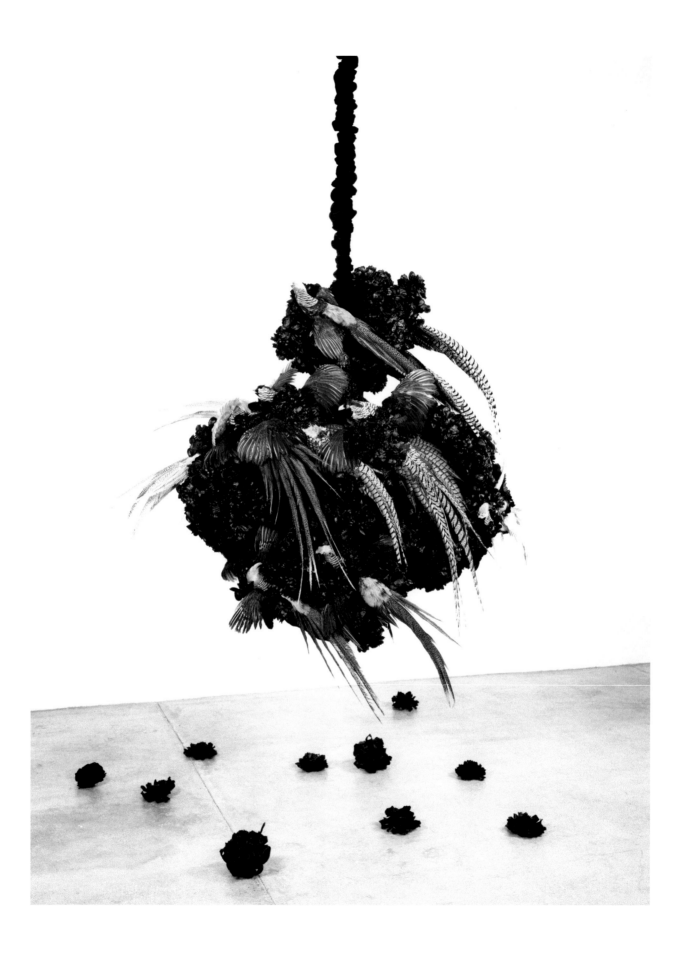

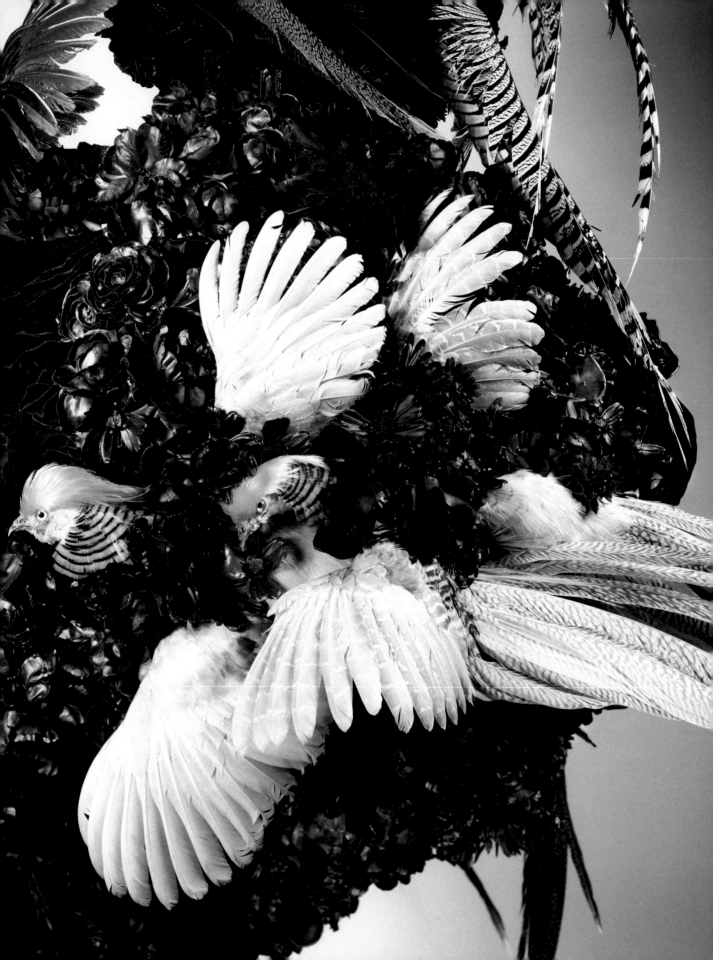

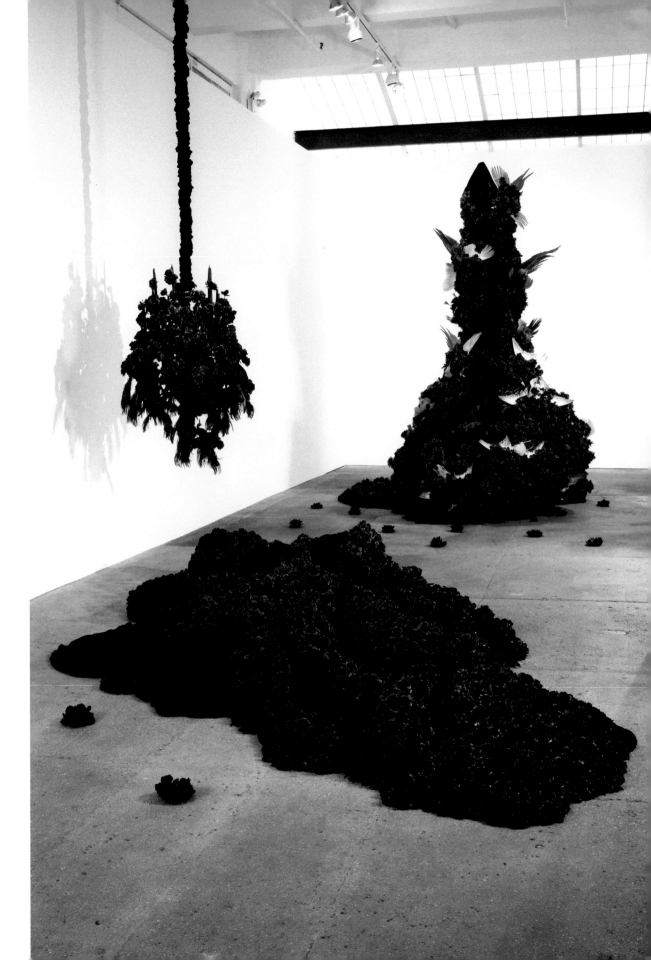

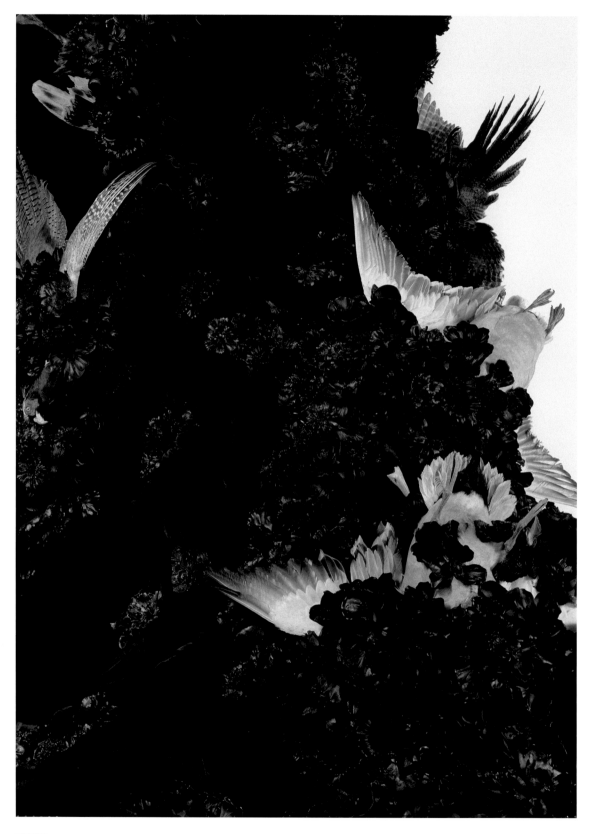

DETAILS
Untitled #1180 (Beatrice), 2003–08

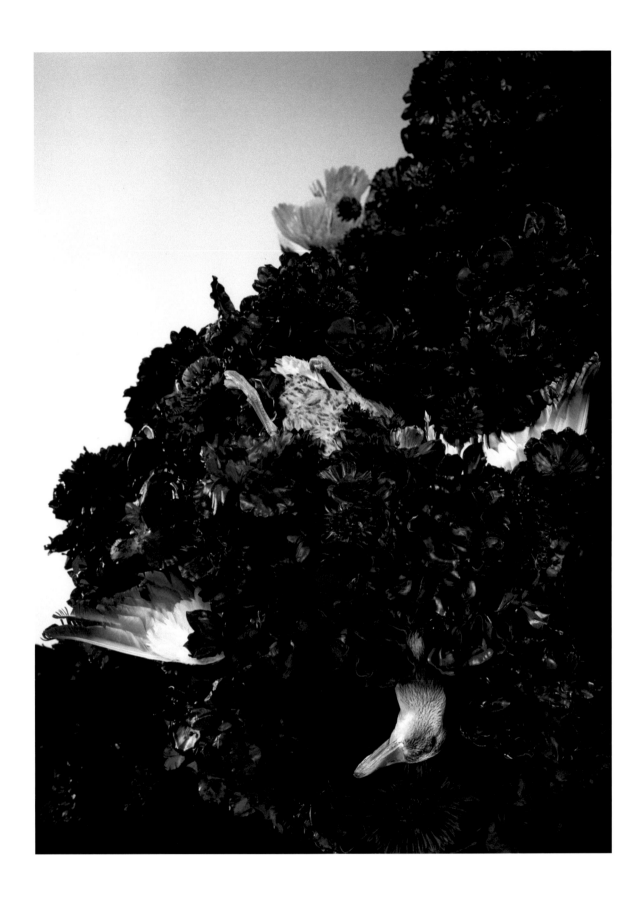

Untitled #1234 (Tom's Twin), 2007–08

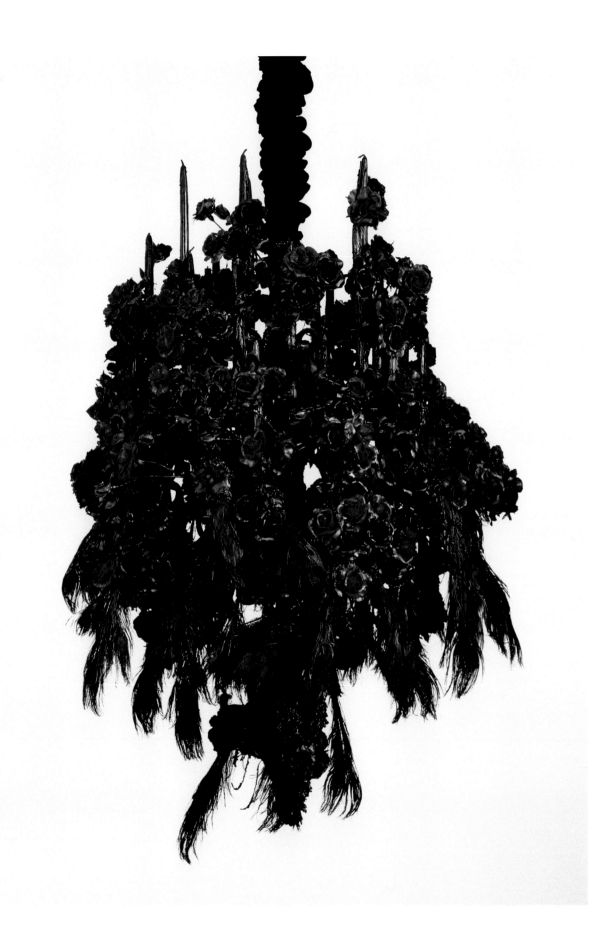

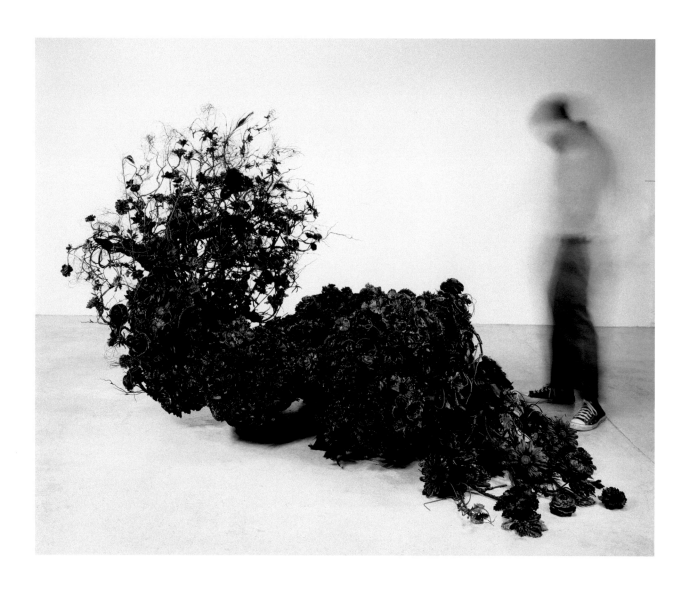

Untitled #1181 (Dante's Daphne), 2004–06

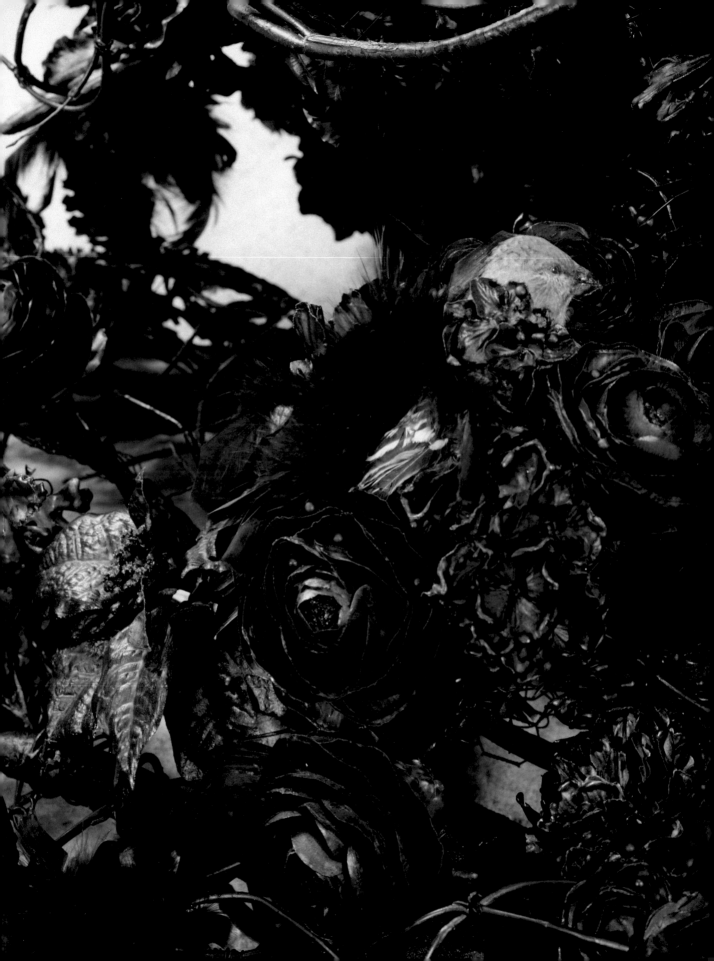

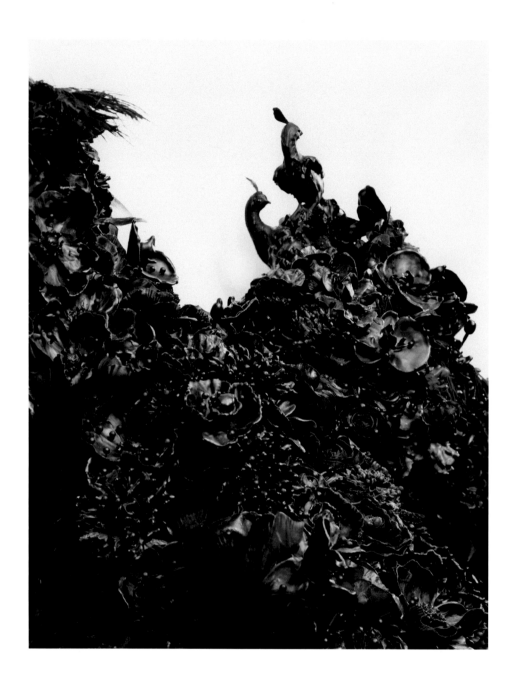

Untitled #1203 (Camel's Back), 2005–07

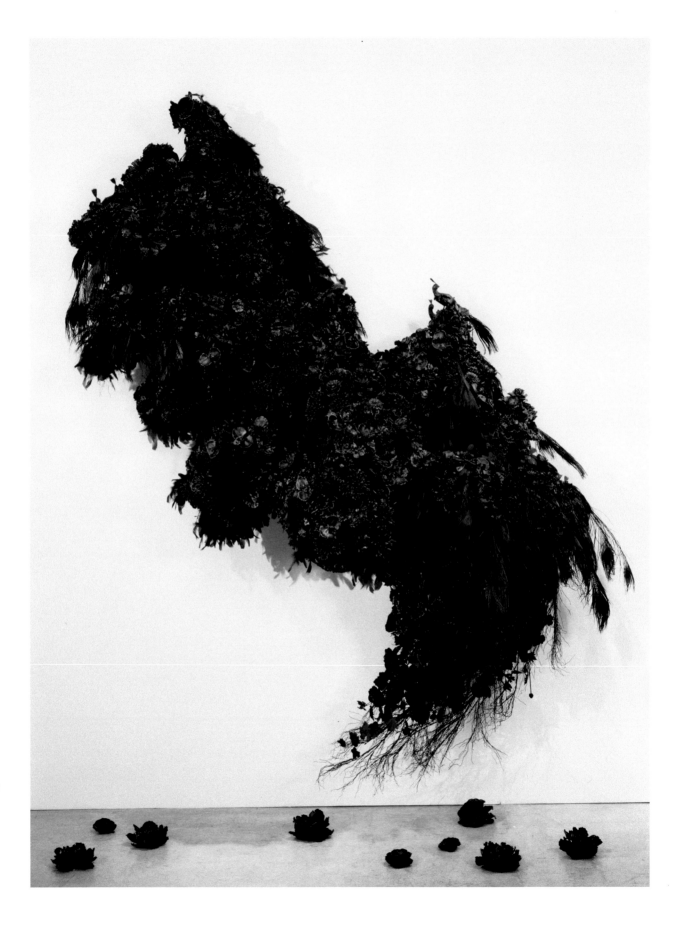

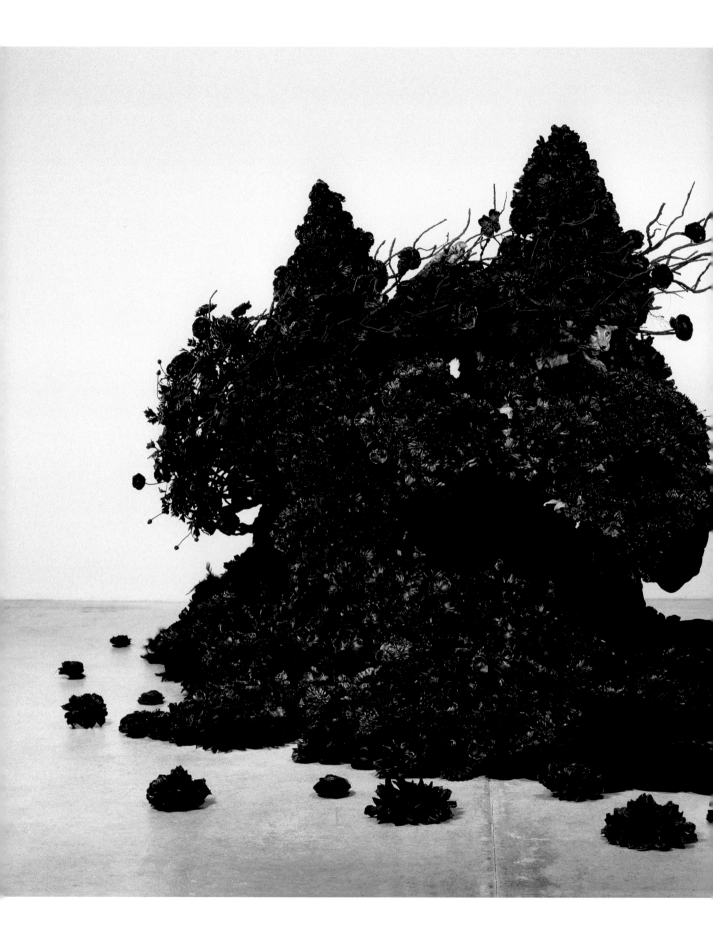

Untitled #1205 (Virgil), 1997–2008

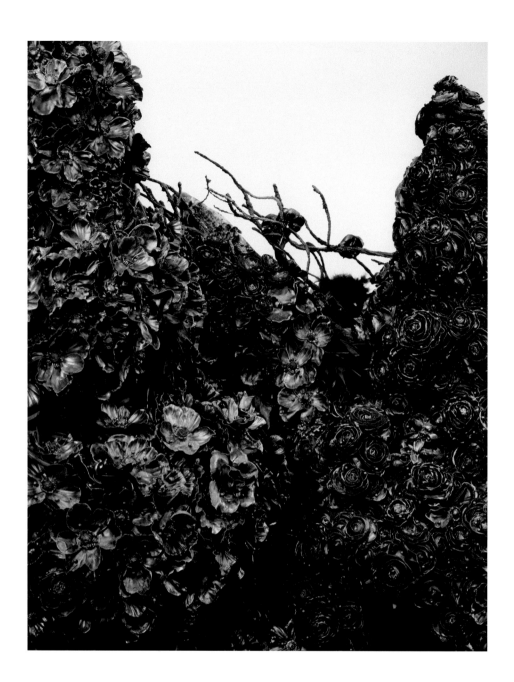

DETAILS
Untitled #1205 (Virgil), 1997–2008

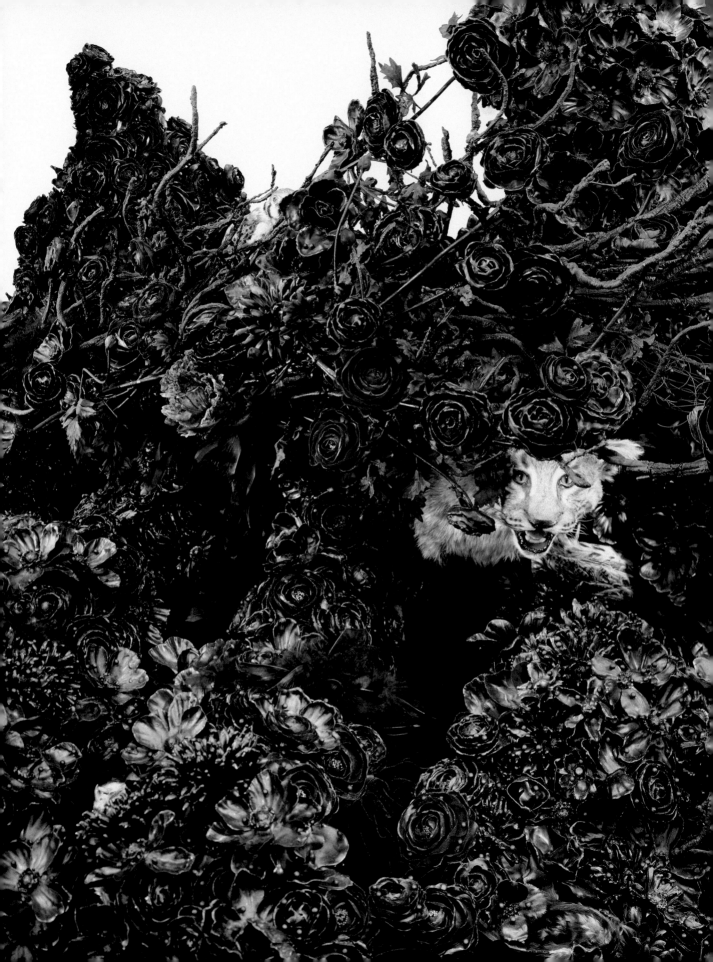

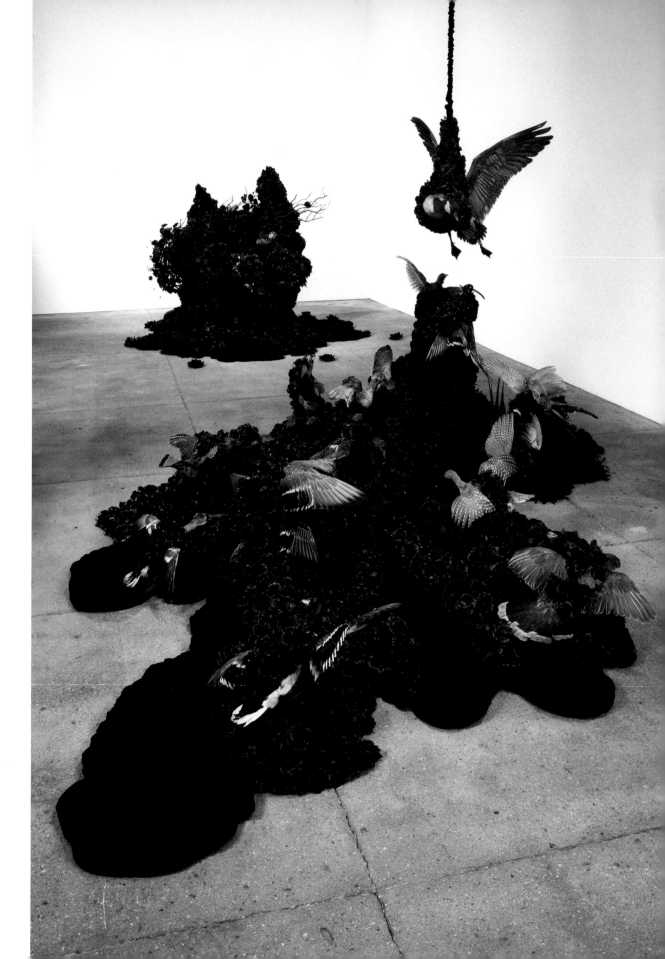

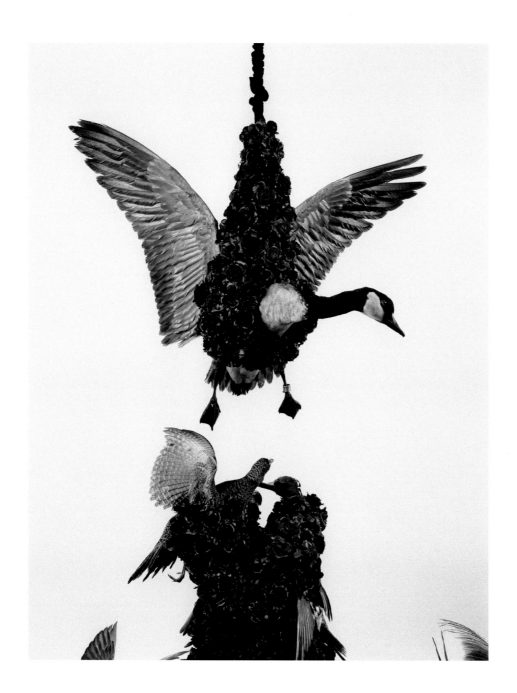

DETAILS
Untitled #1240 (Black Cloud), 2007–08

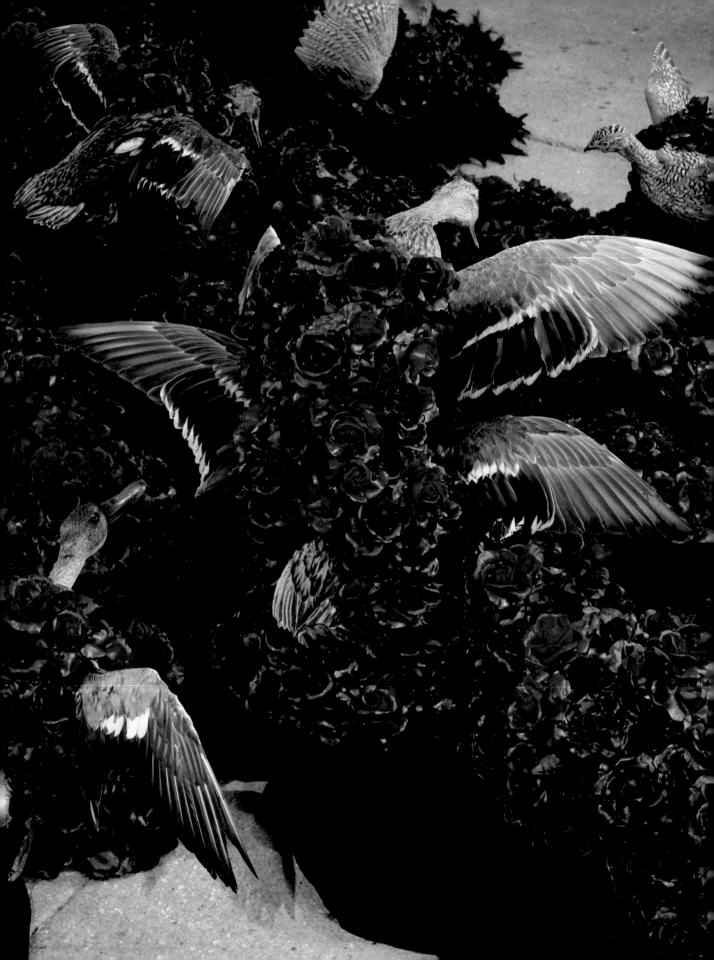

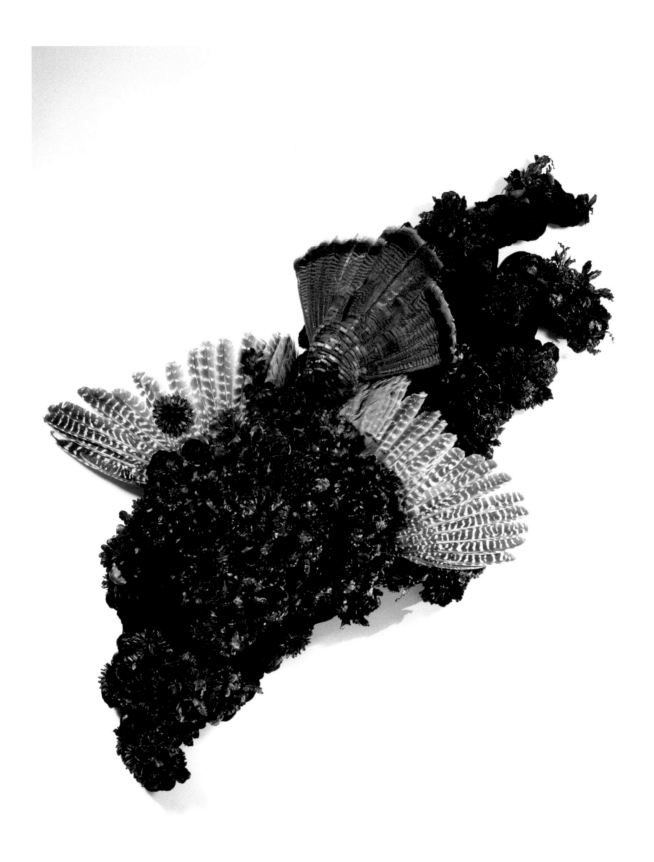

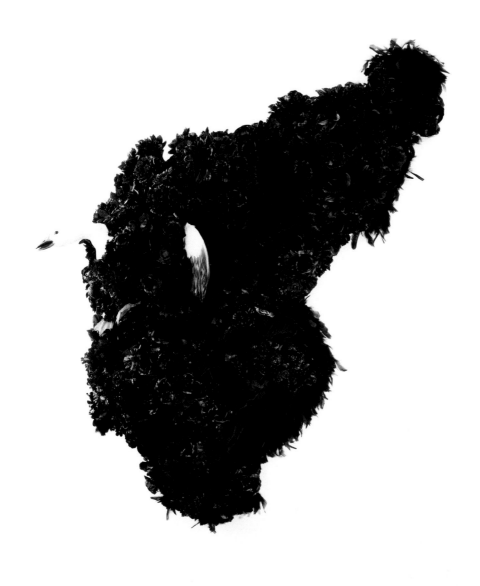

Untitled #1292 (Scarlett), 2008–09

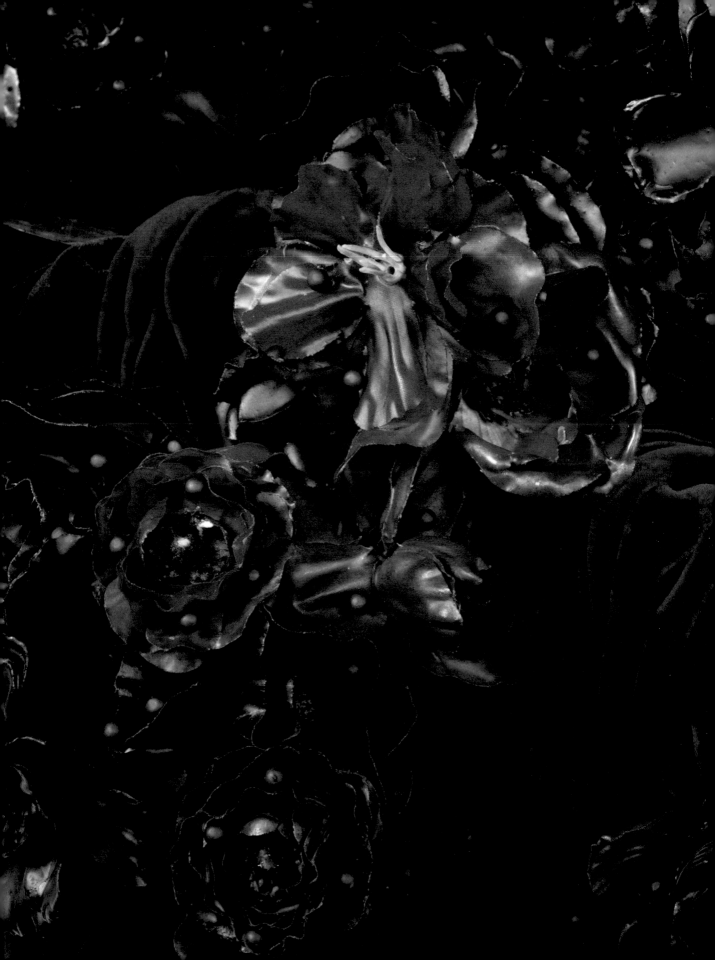

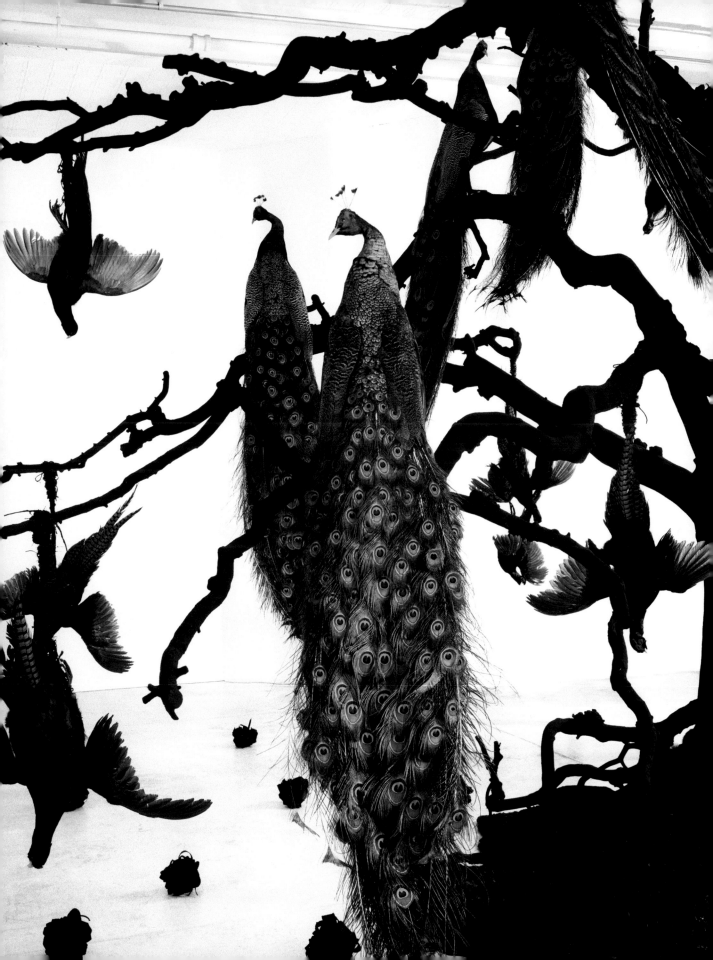

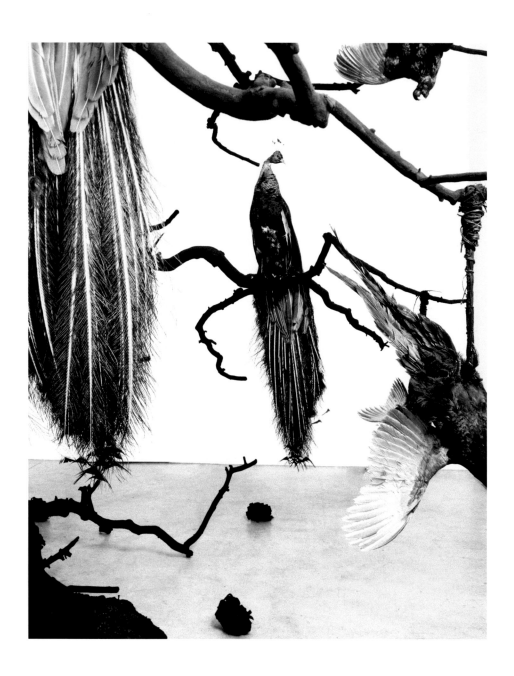

DETAILS
Untitled #1336 (Scalapino Nu Shu), 2009–10

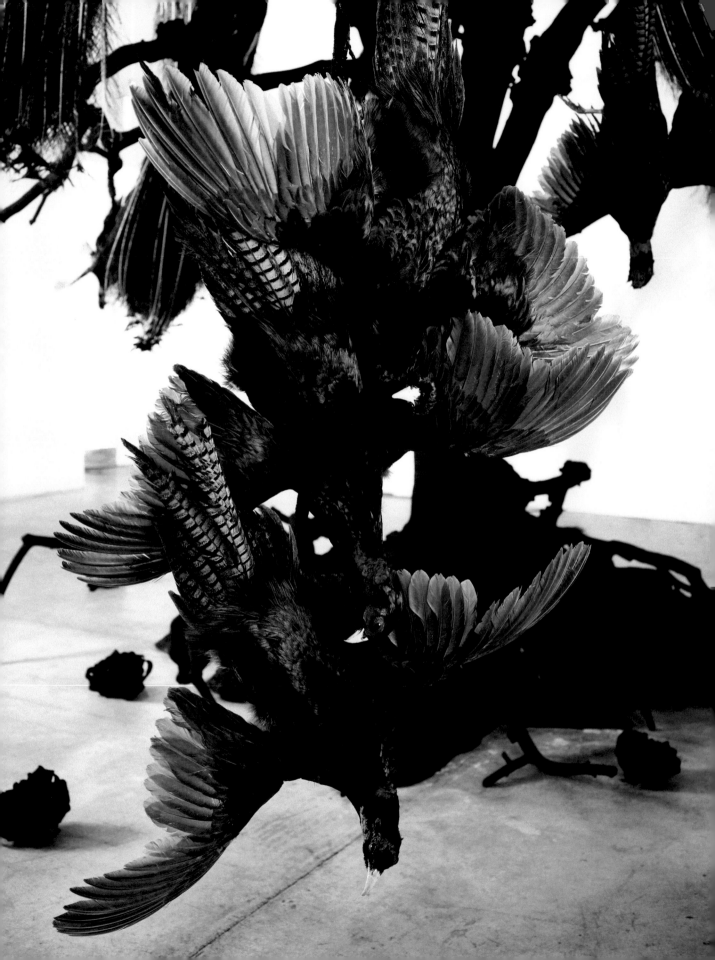

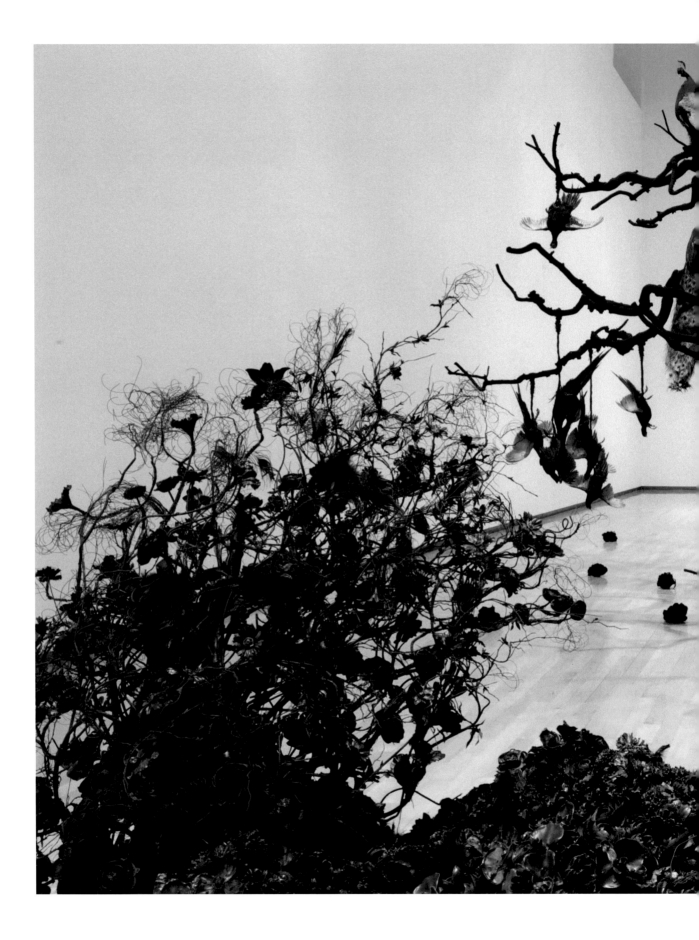

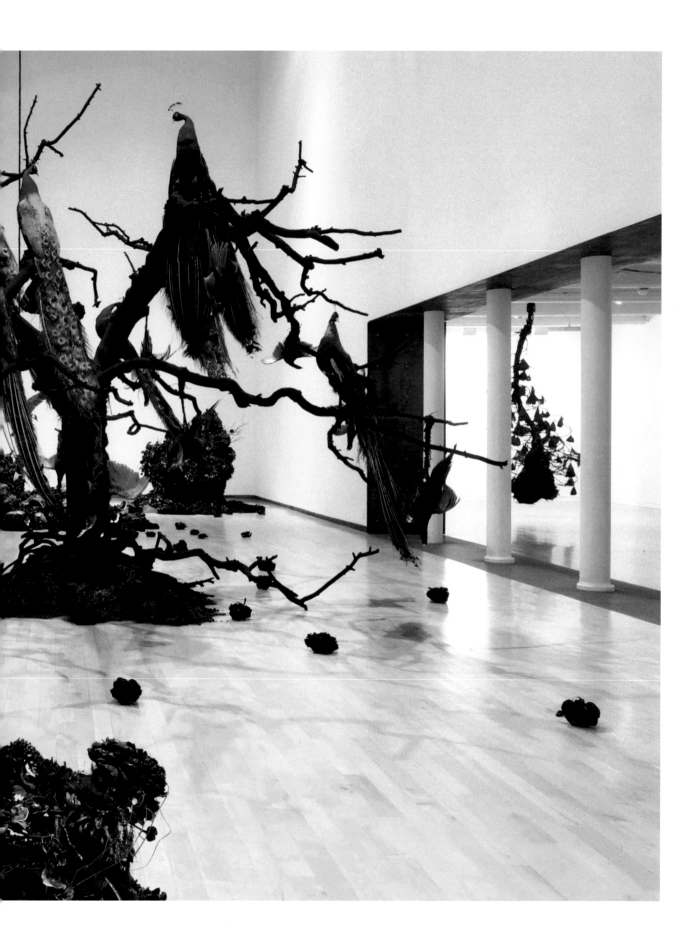

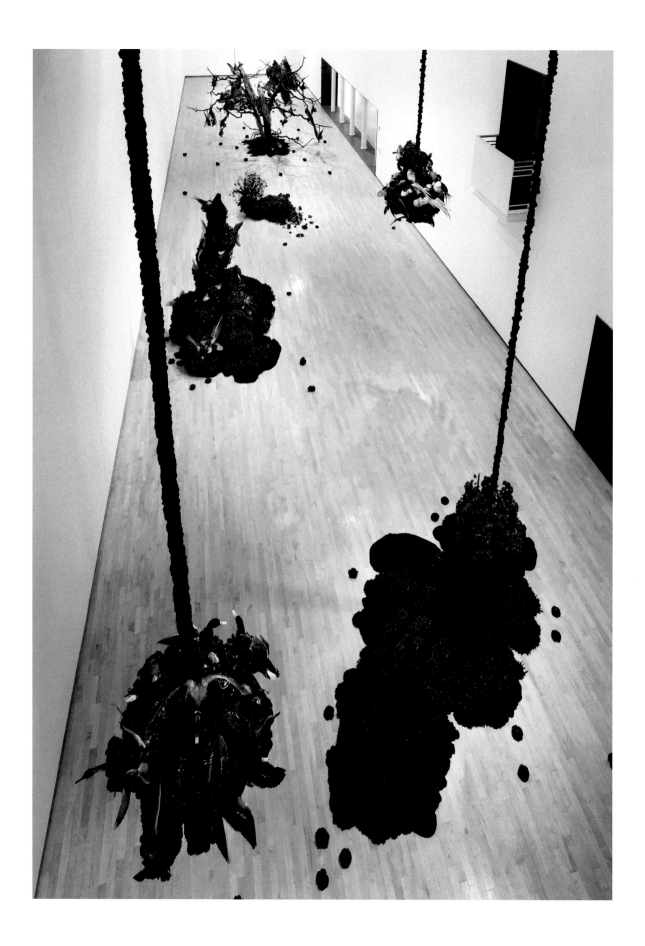

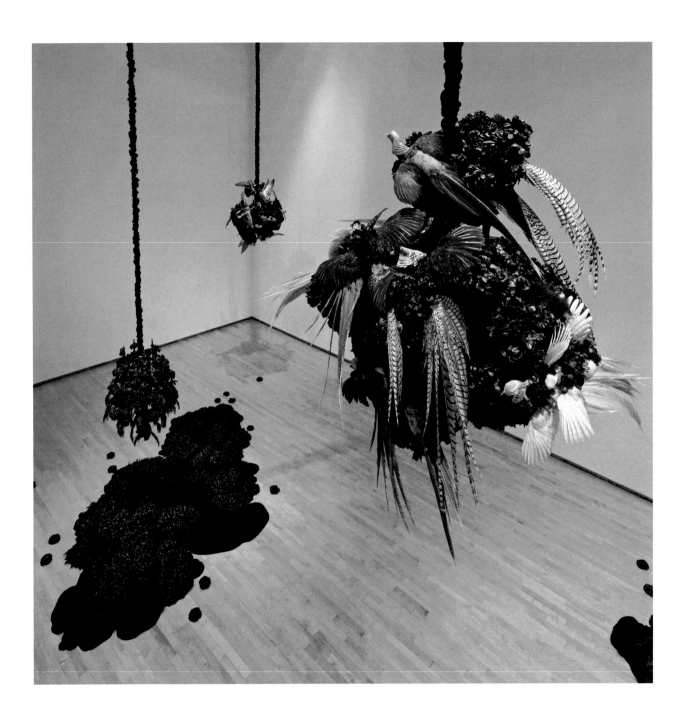

INSTALLATION VIEWS
MASS MoCA, North Adams, 2010–11

The Omega Point
or Happy Birthday Baby

by A.M. Homes

It is the kind of day farmers, when there were still farmers, would have dreamed of. The sky is brilliant blue, the plants are newly green, the air fresh and clean as though it had been washed, tumbled dry and neatly folded the night before. It is the kind of day you never forget.

"Hasn't been a day this pretty since the day you were born," Mary Grace Mahon says to her granddaughter.

"You didn't know me the day I was born," Ruby says.

"Oh but I did," Mary Grace says.

"Not possible," the girl says.

"In my heart of hearts I knew you'd be here soon," Mary Grace says.

"I was born in China, Grandma. The people in China didn't even know when I was born and when I was born Mama didn't even know she was going to adopt a baby."

"I knew," Mary Grace says, "I knew it all along, even before your mother was born, I knew that you'd be coming along."

"Why do you wash the wax fruit?" Ruby changes the subject.

"It gets dusty and then sticky and then it starts to look furry."

"Why do you even have wax fruit?" Ruby asks.

"Appearances are important," Mary Grace says. "I like the bowl to look full."

"I was old when my mother left me at the

orphanage," Ruby says.

"How old?" Mary Grace asks.

"Between nine and ten," the girl says.

"But you're just seven now," she says.

The girl shrugs, as though that's irrelevant, "I came from China in a box. I cried the whole way home, it wasn't very nice," she says.

"You came from China in your mother's lap," Mary Grace says. "I was there, I went along for the ride." What she doesn't say is that in China they looked her in the eye, in a way no one had before, "Interesting," they said. "Very," she said, and they left it at that.

"Here is your daughter," they said, handing the child to her daughter Eliza.

"Why did my mama leave me in a box?" Ruby asks.

"The box was all she had, it was meant to keep you safe." Mary Grace goes into the kitchen and brings out a small wooden crate that some oranges had come in. "If you put newspaper or blankets in here, this would be a safe place for a baby."

Ruby takes the box from Mary Grace, lines it with napkins from the dining room table and arranges the wax fruit in the box. She puts the box down in the center of the dining room table.

"Does that look comfortable?" she asks.

"Are you talking to the fruit?" Mary Grace asks. Ruby doesn't answer. "I have a question for you; what does it mean that today is a professional day at your school?"

"It's teacher training," Ruby says.

"Aren't they already trained?"

Ruby rolls her eyes. "They do special things like make the cafeteria menu for the rest of the year and they do bonding exercises."

"Like gluing themselves together?" Mary Grace asks.

Ruby is looking at the pictures on the mantle in the dining room. "Why are there no pictures of your father?"

"He died before I was born," Mary Grace says.

"That's not true," Ruby says.

"How do you mean?"

"You once showed me a letter he wrote," Ruby says.

"From before I was born," Mary Grace says.

"It said 'thank you for the photograph of our daughter, Mary Grace.'" Ruby says.

"You have a very good memory," Mary Grace says, leading Ruby to the rear window. "Look at the birds," she says, pointing to the feeder. "The birds are getting bigger and bigger, have you noticed?"

The child looks intently, "I can see them growing," she says, "watch." The birds peck at their food and then as though realizing they are being studied, they pivot, tilt their heads, spread their wings — showing off. They turn towards the glass, beady black eyes meeting Mary Grace's and Ruby's, one on one.

"I wonder what they see when they look at us?" Mary Grace asks.

"Monsters," Ruby says.

A man, no longer young, but not exactly old, wearing a black hat that floats somewhere between preacher and cowboy with gemstones around the brim, walks into Paul's Gasoline Station and Mini-Mart, his shoes smelling of gasoline, "I can never decide if I love or hate the smell of gas," the fellow says.

"You get used to it over time," Paul says.

"It's warming up," the fellow says.

"It always does."

"It'll go cold again," the fellow says.

"That's the way it is." Paul says.

"Before it gets hot."

"Every year," Paul says.

"It's misleading."

"Things seem different around here," the fellow takes a look around. "On the one hand we count on everything to stay the same and on the other it's inevitable that it changes."

"I moved things," Paul says.

"Why'd you stop selling chips?"

"Had nothing to do with selling them, it was me, I kept eating them, couldn't control myself; Pringles, Cheetos, Doritos, first one bag, then two, by the time I got rid of them I was up to four and five bags a day and I was always thirsty. Now I sell the dried fruit."

"Anyone buy it?" The fellow taps his credit card rhythmically on the counter.

"No, but at least I don't eat it. You look familiar," Paul says ringing up the gas.

The man cocks his head jauntily to the side, "Voltaire?" he asks.

Paul shakes his head, no, and the fellow spots something on the counter.

"That the unit?"

"Nope."

"Radio?"

"Not exactly."

"Give me a clue?"

"If I knew for sure I'd tell you," Paul says. "I'm thinking it's my dad's ham radio. I found it in my mother's basement, it's like an artifact from an archeological dig."

"You found it in her basement?"

"Yep, you have no idea what's in that basement." Paul says.

"I bet I do," the fellow says smiling like he knows a lot about basements.

"I'm thinking about getting it up and running; there are people out there, just floating, who want to talk. I thought I might set up a little radio station where the chips used to be."

Paul takes a closer look at the fellow. "Did your father used to work at the factory?"

"Nope," the man says.

"Mine did — worked on the gadget. He was proud of it, used to talk like they were making something special, something that was going to change the world like a giant Christmas present. I always pictured something wrapped in colored foil like those holiday chocolates," Paul says.

"Like the Easter bunny," the fellow says. "My father died on Easter Sunday, 1955."

"They made the trigger," Paul says. "It was all go, go, go, until they dropped it and then you didn't hear so much."

"The talking stopped. Silence," Paul says.

"Not a word," the fellow says. They each take a long breath.

"'Infinite Capacity,'" Paul says. "That was their motto, they thought they knew what it meant. He wasn't the same after that, at least that's what my mother says. I was too young to remember. I don't think they knew what they were making. They weren't scientists, they were tinkerers."

The two men stand in silence, the fellow looks at the television set on the counter — the ball game is on, "Who's winning?"

"The other guys," Paul says. "Was it just the gas or something else you wanted?"

"I'll take a couple of the fruit leathers and a bag of popcorn — how come you still carry the popcorn?"

"I hate the sound it makes when you chew it, like Styrofoam." Paul hands the fellow a bag, "Take it, it's on me."

As he's leaving, the fellow reaches into his pocket and flips Paul a coin, "for good luck."

"Walking Liberty," Paul says, turning it over in his hand. "Haven't seen one of these in a long time, we used to get 'em from the tooth fairy."

The stranger smiles, flashing gold rims around his teeth. "Tooth fairy," he says, "now that's a calling."

"I owe you some change," Paul calls after the fellow, "or at least more popcorn." He yanks several more bags off the rack.

"You owe me nothing," the fellow says. As he walks out, the gems on the brim catch the light and a rainbow explodes out of his hat.

Deep into the seventh inning, Paul spots someone at the pumps trying to fill up a two-liter soda bottle. He rushes out. "You can't just gas up a coke bottle. You could blow us all to kingdom come. Look at you — you're an accident waiting to happen."

"I walk a very long time to your station to say hello and this is your welcome?" The man is Chinese and speaks with a thick accent.

"I run out of gas on hairpiece curl, my car just stopped in the middle of the road... I walk from there."

"Hairpiece curl?" Paul asks.

"No mock me," the Chinese man says, "I have accent. You have accent too — I no mock you. Asshole. I have lousy life — bad harelip, bad surgery. Everywhere I go, I deal with people like you. Your father would be ashamed, your father was good man open to all and you are like today's man — mean all around."

"You knew my father?"

"Of course I did, that's why I come to you now. Your father fix my father's car forty years ago and now like bad date my car break down right in the same spot as my father's — what are the chances of that?"

"Slim."

"I say so too," the man says.

"What's your name?"

"Walter," the man says. "Everybody call me Walter."

"Walter, I will help you with your car. I have a niece from China," Paul says, thinking he's doing a good job.

"You and everybody else," Walter says. Walter wears a black coat, mid-length, and carries a classic wide briefcase like a sample case or a classic lawyer's briefcase. He carries it everywhere, into and out of the gas station office.

The pay phone on the wall of the mini mart rings, Paul picks up.

"It's your sister," his sister Eliza says. Eliza owns a flower shop downtown with a sign in the window that says "by appointment only." She doesn't like surprises.

"Can I call you back?" Paul asks.

"Why?"

"I've got someone here."

"Who?"

"A guy."

"What kind of a guy?"

"The kind of guy who has car trouble."

"Why didn't you just say so."

"I did actually."

He covers the phone and whispers loudly, "My sister, she's a talker."

"I'm in no hurry," the man says, "I got where I am going."

"We need to talk about your mother," his sister says.

"Why is she 'my mother' when she's your mother too?"

"When there's something wrong she's your mother and you know that."

"What's wrong?"

"She's losing her mind."

"She's ninety-three years old, it's bound to happen."

"It's not that she's senile, it's that she knows too much."

He turns off the television on the counter, "What do you mean?"

"This morning when I dropped Ruby off she was saying things that on the one hand made no sense and on the other seemed perfectly logical, or more than logical — like she knew something. She was talking about the weather and how the weather used to let you know what time of year it was and how now, on any given day, it could be any day of the year.... And then she went on a tear about the bats and white nose fungus and the collapse of the honey bee colonies and how everything is more interrelated than we realize and we really couldn't get much dumber could we — and then she just glared at me like it was all my fault."

Paul is playing with the half dollar the fellow gave him earlier. "I'm not sure what to say," he says. "Sounds par for the course. And this fella needs me to help him. Can we talk later?"

"Meet me at 3 pm?" his sister says.

"I can't leave the station."

"Fine, I'll come to you."

Walter is buying gumballs from an old penny machine in the corner.

"I'm not so sure I'd eat those," Paul says. "Hard as rocks."

"I like it," Walter says. "It give gum ball with fortune written on it, like have a nice day. I remember this machine, long time ago the same machine used to sell a small hand of salty peanuts."

"That's right. Back in my dad's day, the machine sold salted peanuts. He loved his peanuts. Let me just find my keys and we'll get ourselves a can of gas and drive up to your car — where'd you say it broke down."

"Hairpin curl," Walter says slowly. And this time Paul listens more carefully.

"Hairpin turn?"

Paul drives the Chinese man to his car, all the while telling the story of how the Mahon family has been repairing cars ever since Ransom Olds and Henry Ford started making them. "In fact, my grandfather and his brothers used to sell buckets of water right up there on the hairpin turn to cars whose engines overheated. They'd carry buckets up the Mohawk trail — a nickel a bucket. And they'd pick blueberries on the way down, fresh-picked blueberries, warm from the sun, bursting with flavor. What business did you say you're in?"

"I am low profile delivery man, advance man. I come and I go."

At the Holiday Inn downtown two Chinese men in mid-length black coats check in. They are given a room with two double beds. As soon as the door closes, they take off their coats and do gymnastics tricks, jumping from bed to bed, turning flips in the air — they are former gymnasts and strong men — they lift their beds over their heads for exercise.

Back at the house, Mary Grace is making lunch for Ruby, "Would you like me to tell you a story?"

"What kind of a story?" Ruby asks.

"A true story," Mary Grace says.

"Non-fiction?"

"Yes?"

"That means it's real?"

"It's a story that I've never told anyone before."

"What's it about?"

"It's about us."

"You never told anyone — not even my mother?"

"Not even your mother."

"Is it a secret?"

"It was — until now."

"My mother doesn't believe in secrets."

"Neither do I; perhaps there's a difference between a secret and something that just hasn't been said?"

"I'm listening," Ruby says.

Mary Grace takes a deep breath, "My father was Chinese."

Ruby looks at her suspiciously, like it's a joke.

"He was born in China in 1860."

"Were his parents Chinese?"

"Yes."

"Does Mama know?" Ruby asks, suddenly a little anxious.

"No, she doesn't."

"How come?"

"I never told her."

"Tell me more," Ruby says.

"My father's family were poor farmers in China. He came to California by boat when he was ten to live with his uncle. And when the shoe factory here went on strike, seventy-five Chinese men from San Francisco came to town and worked in the factory."

"Your father came here?"

"Yes. And he became friendly with a local family and soon he worked for them and when they went south to Florida — he went with them. And your great-grandmother, who was friendly with one of the girls in that family, went to Florida too. And she and my father become very close."

"Were they married?"

"No, they were never married."

"What did she like about him?"

"He was very clever, always inventing things and he was very kind to animals. He had a horse that he spoke to like she was a person and my mother liked that."

"Pop-pop also invented things," Ruby says, speaking of her grandfather.

"Yes, that's right."

"I never met Pop-pop," Ruby says sadly.

"You would have liked him a lot," Mary Grace says. "So after a while my mama realized that she was going to have a baby. She bought herself a train ticket and a gold wedding band and came back home big with child."

"Why did she buy a wedding band?"

"In those days it wasn't proper for a woman to have a baby on her own. When people asked where is your husband, she'd look sad and say, 'He was killed in the war.'"

"What war?"

"The first big war; World War One."

"Why didn't she marry your daddy and live happily ever after?"

"Because people weren't so forgiving," Mary Grace says, realizing that some things are very hard to explain. "And so she was very pregnant and tired of waiting for the baby to come, and so she went out for a walk and she just kept walking and walking. She walked right up the mountain and around the mountain and back down the mountain and on her way down, the baby came."

"You?" Ruby asks.

"Yes."

"And when people saw me they said my face looked a little odd. It's the face of grief my mother would tell them, her father died before she was born."

Ruby looks at her grandmother, "I think your face looks pretty, old but pretty."

"Thank you," Mary Grace says.

"Did you ever meet your daddy?"

"No. He died a long time ago, but he left something behind."

"What?"

Mary Grace opens her hand.

"An orange?"

"My father was known as the Citrus Wizard; he invented the orange we eat today."

"How did he do that?"

"Cross-pollination. He combined the strengths of different plants, something he learned from his parents and from watching honey bees, and he created an orange that didn't freeze on cold nights."

She drops the orange into Ruby's hand. "It's a good story isn't it?"

Ruby nods.

"Should we eat our lunch at the dining room table or outside under the apple tree?"

"I'm afraid of the bees," Ruby says.

Mary Grace opens the back door, "and the bees are afraid of you," she says, handing Ruby a plate and a glass of milk.

They go out back; Mary Grace is distracted by the weather, by the fact that everything is out of order. "Hydrangea and peony are up too early this year," she says. "Something is coming into the yard, taking over the apple tree. Look,"

She says, "you can see it, something dark coming up from the bottom, spreading." "Everything is vulnerable," she says, shaking her head. "When we were kids this fence wasn't here and we used to tip-toe next door and steal Mr. McGregor's apples. The trick was to take as many as you could before he noticed."

"Did you live in this house when you were my age?"

"I did and then I moved out when I got married and moved back in when mother began to fail."

"How many apples did you take?"

"As many as we could carry."

"Did you get in trouble?"

"No. I don't think he minded as long as we ate them—but Mr. McGregor used to like to try and scare us."

"How does an apple tree make apples?"

"You need two different kinds of apple trees near each other in order to make fruit. Bees to carry the pollen from one tree to the other; a tree on its own is barren."

"So," Ruby says, "if your father was Chinese, that means my mother and Uncle Paul are Chinese too?"

Mary Grace nods.

"Do they know?"

"No."

"We should tell them."

"We should," Mary Grace says.

"Tonight," Ruby says.

"How old are you?" Ruby wants to know.

"What makes you ask?"

"I was just wondering how many peanut butter sandwiches you've eaten in your whole life."

"It's funny," Mary Grace says, "I only eat peanut butter with you."

"What time is it in China?"

"Right now?"

Ruby nods.

"In China today is tomorrow."

In the afternoon, the wind shifts, becoming hot, urgent, swirling, picking up whatever it can lift, twirling what it carries, around the houses, the trees, the town, up to the mountain, in a kind of rhythmic, purposeful twisting, turning dance, as if trying to shake something off, trying to get relief.

Eliza blows into the office of the mini mart carrying a vase of flowers.

"For me?" Paul asks.

"For Parker, but I didn't want to leave them in the hot car."

"Parker, the guy at the cemetery, the guy with the tattoo of Jesus on his back?"

"That's him. Just before Mr. Maloney died he gave Parker enough money to buy flowers for Mrs. Maloney's grave every week in perpetuity."

"So what is it about your mother that's plaguing you," Paul asks.

"I don't know exactly, she's got something up her sleeve, that smug, 'knowing' look she gets — pursed lips like she's lived so long God himself has hired her as his personal advisor."

Paul says nothing.

"And she's been very organized like she's...."

"Planning a trip?" Paul asks.

"Something like that," Eliza says.

"What's she going to do, run away? It's your anxiety talking; anytime Mom or Dad tried to leave town even just to go to Pittsfield you practically had a breakdown. For forty-five years no one in this family has been able to go more than a couple of miles from home base."

"We all have our limits," she says.

"I don't know how you made it all the way to China and back," he says.

"Valium," she says. "I took Valium and I took mom. What is that thing?" She points to the old metal box on the counter.

"That's the question of the day, whatever it is, still works." Paul turns it on; the red light warms then glows, like a maraschino cherry deep in a glass of ginger ale. "I'm thinking it's something Dad made; I found it in the basement."

"It's not the unit is it?"

He shakes his head. "I don't think so," he says. "You never really knew what the unit was — did you?"

"Not really," she says. "Whenever he said anything about it mom would shush him, I always thought it was something related to private parts."

"He called it the unit or sometimes the peacekeeper."

"Whatever it was it's probably still in the basement."

"This thing is a receiver of some sort, like a ham radio. I'd like to get it up and running, see who I can find 'on line' the old fashioned way." He turns it off and then on again — the red light glows a little brighter.

"Is it wise to turn on things when you don't really know what they do?"

"Like what? You think by turning this on I'm dimming the lights in China?"

"You never know."

"Maybe someone will call me, a voice from the past," Paul says.

"Perhaps you're sending a signal," Eliza says.

"And perhaps someone will signal me back." Paul turns the machine off and on again and again. "Remember how Dad and I were always making stuff with our soldering guns?"

"Who could forget the smell of burning plastic and molten whatever, toxic fumes coming upstairs, I think that's what started my headaches. What happened to the chips?" she says, looking around.

"I ate them."

"All of them?"

"Pretty much."

"I was hoping you'd have chips," she says. "I was looking forward to it."

"Fruit leather," he says, offering her some.

"No thanks."

Paul flips the half dollar he got earlier into the air, Eliza catches it, takes a look. "Tooth fairy paid you a visit?"

"Perhaps," Paul says.

She puts her hands over her eyes, "Everything is too bright, too clear, like the day itself has gone past full daylight and into something like Kodacolor explosion."

"You see rainbows?" Paul asks, thinking of the man with the hat from earlier.

"I'm getting one of my headaches. Can I use your phone?" Eliza goes to the old pay phone and dials Mary Grace.

"Where are you?" Mary Grace shouts. "I can hardly hear you."

"On the pay phone at the gas station. It's the same damn phone that's been here for thirty years, I'm surprised it still works. I wanted to see if you're okay to keep Ruby for the afternoon, I'm getting one of my headaches."

"We're fine," Mary Grace shouts. "Go home and lie down. Drive careful, I think there's a storm coming."

—

Mary Grace hangs up and turns to Ruby, "Your mom has been getting headaches ever since she was a child. I think it's things she knows but doesn't want to know trying to get out; your mother is very smart."

"Like me," Ruby says.

"Just like you."

On her way home, Eliza stops at the cemetery. In the distance, two men are digging a grave. Parker, shirtless, is down on his hands and knees with a small clipper trimming the grass around a headstone, like he's giving it a haircut or a shave. The glossy sweat on his back coats a large byzantine tattoo of Jesus, catching the afternoon light in such a way that Eliza feels the face of Christ looking at her demanding something.

"Who died?" she asks, nodding towards the gravediggers in the distance.

"Don't know yet," Parker says.

"I got your flowers." She holds out the vase.

"Appreciate it," Parker says, turning around, reaching into his pocket for the money. His chest and his arms are covered in tattoos, stories waiting to be told.

"Strange weather," she says, making conversation.

"Yep," he says, "there's something in the air, almost like little invisible flakes, shards of light—just landing on things."

As the wind picks up a hum comes over the hills, low grade and musical, more like a chant. It starts low, rising up, and then stops as though to catch a breath and begins again; a hum like the wind, like a Buddhist song, like the elongated om in a yoga class, ascending and descending.

—

The widow from across the street comes knocking on Mary Grace's door. "We're in for it now," the widow says.

"Late for snow and too early for blight," Mary Grace says, putting up the kettle to boil. Ruby, playing on the kitchen floor, listens to every word.

"When plagues are upon us," the widow says, "deliverance soon follows."

Mary Grace says nothing, what is there to say?

The widow continues, "What time of year is it—harvest?"

"Spring," Mary Grace says.

"Is that right?" the widow looks at the calendar on Mary Grace's wall. "Did I miss Christmas?" She shakes her head. "When you live long enough you see it all—the great blizzard, the unending rain, the big fire, the quake before dawn, the rising lake, the lowering trees, the white noise. There were always those who knew and those who didn't want to know," she clucks.

The two women have each lived a long time and speak in a kind of code. Mary Grace takes out a tin of tea.

"And those who liked it the way it was before," the widow says.

"And always some who didn't want to know, who ignored the warning," Mary Grace says.

"Was that the end of it?" the widow asks. 'Wasn't there more? Didn't they know that one day it would come back?"

"You and I have lived a long time, we've been through it all," Mary Grace says. "It comes and it goes."

"What are you talking about?" Ruby demands.

"We are talking about life on this good earth," the widow says.

"Will you stay for tea?" Mary Grace asks.

"I'm going under," the widow says, turning to leave.

"Be sure to take a flashlight," Mary Grace reminds her.

"You're welcome to join me," she says, filled with hope—no one wants to be alone in the dark.

"We'll stay," Mary Grace says.

"If anything interesting happens come get me," the widow says, leaving.

"Where is she going?" Ruby asks.

"Years ago some folks built shelters underground in case of bad weather or war and stocked them with food and water. Your grandfather and I never went for that kind of thing. We're more optimistic than some of the others. Do you know what I used to like to do when a storm was coming?"

"What?"

"I liked to ride my bike up Greylock."

"That sounds dangerous," Ruby says; she is by nature cautious.

"Yes—I suppose, but it was very exciting. I saw all kinds of things; if you get up high enough, sometimes it felt like you were Zeus on top of Olympus above the storm or you could watch it move from one side of the mountain to the other, you could almost get right up inside it. Would you like to do that with me sometime?"

Ruby shakes her head, no. "I'm more of an indoor person," she says and goes back to her game.

"Look at the birds," Mary Grace says, noticing the birds just outside, making sudden, quick preparations, as though they have some kind of back-up plan, some emergency effectiveness training that they are putting to the test. The winds are picking up, though the sky remains clear—but for some high white clouds.

"Tell me more," Ruby says, to distract herself. "Is that the ring your mother wore?" She points to a ring on Mary Grace's finger.

"Yes it is."

"The golden ring?"

Mary Grace nods.

And the storm is upon them. Fat raindrops splash against the windows, thunder slams, the window panes shudder. The winds spin, turning in ever tighter circles, at one point seeming to focus entirely on the apple tree, whirling around it, leaving the tree trunk and branches coated with ancient black sand—crushed onyx, obsidian, druzy. As quickly as the storm was upon them it is over.

—

Paul arrives soon after. "Quite the storm," he says, "the streets are covered with branches, lines are down."

"Quite," says Mary Grace, distracted. She is once again looking at the birds for clues. They appear to be flying around the house, circling.

"Just wanted to make sure you two were alright. We lost power so I closed up for the night. How is it that your lights are on?" Paul asks.

"I don't know," Mary Grace says, going back into the kitchen, busying herself with dinner.

"I met the funniest fella today. A Chinese man came to town, said he'd been here before and that he knew Pop."

"Hmmm," Mary Grace says, winking at Ruby.

And then she remembers the widow across the street; "Can you two knock on her shelter door, let her know the weather is over for now and see if she'd like to join us for dinner?"

Ruby and Paul dutifully go across the street and knock on the shelter.

The widow won't come out. "They say more is coming soon," she says, "Things don't happen just once."

"Would you like us to bring you a plate of supper?" Paul asks.

"Oh," she says, "thank you, that would be nice."

At the Holiday Inn downtown the two Chinese men ask about dinner. "We have been looking forward to something special. We are craving the McDonald's. Is there one near here? Do they have a Happy Meal? It comes with a prize inside like a fortune cookie? Have you ever had one?"

Ruby calls her mother from the phone in Mary Grace's kitchen. "Hi Mom," she says.

"Hi Ruby," her mom says.

"Grandma wants me to invite you for dinner."

"That sounds nice—but I still have a headache, are you okay?"

"I'm fine," Ruby says. "Grandma told me something interesting."

"What did she tell you?"

"We're Chinese."

"You're Chinese," her mother says.

"So are you," Ruby says.

"Please Ruby, don't start."

"What, Mama, I'm just telling you what Grandma told me."

"Can you put her on the phone?"

Ruby looks at Mary Grace who is standing right there listening. Mary Grace shakes her head. "She can't come to the phone right now," Ruby says. "She's very busy."

Ten minutes later Ruby's mom arrives wearing her cranial ice-helmet, looking like an angry linebacker. "I don't know what you're up to but I'm not liking it," she says to her mother. "You are confusing Ruby."

"Ruby is not confused," her mother says.

"Well then I must be."

"Perhaps, but it's not your fault," her mother says, going into the kitchen for the supper plates.

"Can you and Ruby set the table?" Mary Grace asks.

"I'm not hungry," Eliza says, "I'm nauseated. Why is this orange box on the table?"

"That's the box I came in" Ruby says.

"No it's not," Eliza says.

There is an old baby doll, like the baby Jesus, in the Clementine crate on the dining room table.

"Well, it's like the box I came in," Ruby says. "We were playing trip from China."

"Why is it I can't even just have a headache and lie down for two hours without the whole world slipping out of control?" Eliza asks.

"Maybe you want more control than is possible?" Paul says.

"There is something I need to tell you," Mary Grace says, when they are all in their places.

"Are you thinking the end is coming soon?" Eliza asks, worried.

"It's inevitable," Paul says.

"Ruby, go in the other room and watch television," her mother says.

Ruby doesn't budge.

"I have some information," Mary Grace says.

"What kind of information, like top-secret information, like someone from the government is going to come knocking on the door?" Paul asks.

"I was born out of wedlock," she says. "My father was Chinese."

"Your father was killed in the war," Eliza says, correcting her.

"It was a lie," Mary Grace says.

"Why didn't you tell us before?" Paul asks.

"I'm telling you now," she says.

"If you'd told us earlier we could have known you better," Eliza says.

"You knew me well enough."

"Did Dad know?" Paul asks.

"I can't remember," Mary Grace says, honestly. "He knew something, I'm just not sure what. I was going to tell him more — but after the gadget he was afraid of things and it seemed best not to say too much."

"Am I right in remembering that sometimes the doorbell would ring and strangers would be standing on the doorstep bringing boxes and crates?"

"Yes."

"They'd just arrive with no warning?"

"That's correct."

"And you'd take the things they brought?"

"Yes, it started in the late 1940s, when this was still my mother's house. And then after she passed, we continued to accept what came — that's just the way it was."

"They just arrived?"

"Yes."

"Men would come?"

"It was never about the men, it was about what they carried, big boxes, small boxes, suitcases."

"Do you ever look inside the boxes?" Paul asks.

"No," she says unequivocally, "the boxes were ours to hold, not to open. Someone will come to open them."

"And what about the unit; how does that fit with the unit?"

"You're conflating the unit with the news from China?" Eliza says.

"Am I? They worked on the trigger at the factory. They built the trigger of the first atomic bomb — the gadget."

"When the men would come they would talk with your father; sometimes your father would take them downstairs and show them what he was working on. They talked about the bonds between countries, not everyone wanted to blow us all to kingdom come."

"The bomb was dropped on Japan, not China," Eliza says. "China wasn't part of it."

"China and Japan are next-door neighbors; they were all working on something."

"I believe the unit is still in the basement," Mary Grace says. "It's meant to work like a magnet, gathering things."

Ruby asks, "When did your mama die?"

"August of 1974. She had a stroke the day after President Nixon resigned; she lost her faith. Nixon was the first United States President who ever visited China. I never understood how her faith became so wrapped up in Nixon but it did. Before Nixon, she loved Eisenhower."

"And am I right in remembering we used to get boxes of fruit every month, oranges, grapefruit, citrus?" Paul asks.

"That's right."

"Who sent them?" Eliza asks.

"I never knew. December 1974, that was the last box we got. After mother died the connection was lost." Mary Grace is suddenly tired.

Paul takes more lamb onto his plate. "I want to be sure I've got this right, you're saying that you're part Chinese?"

"Yes and you are too," Mary Grace says. She is

suddenly a little nervous, flighty, unable to eat.

"Buy Firecrackers, eat Lychee nuts?" Paul says.

"It means only what you want it to mean," Mary Grace says.

"I think we should open the boxes," Paul says.

The doorbell rings.

"I'm scared," Ruby says.

"Nothing to be afraid of," Mary Grace says, going to the door.

She opens the front door and there is a Chinese man holding a large basket of fruit.

"I am returning the kidneys," he says.

Paul comes to the door, "The kindness," he says, translating for Walter. "Come in, come in. It's Walter, the man who had car trouble earlier."

Walter makes a little bow; Mary Grace takes the fruit basket from him.

"In China I am Yao Walter, but here I am Walter Granger, all at once like the name Campbell's soup. My grandfather was digger at the bone cave with Walter Granger of Middletown Springs, Vermont, he had no children of his own, and so they name me after him. No one in my village has ever been named Walter. I hope I am not late," Walter says.

"Not at all," Mary Grace says. "We're just having dinner." Eliza gets another plate.

Ruby pats the empty seat next to her, "Sit here," she says. And he does.

Paul passes the lamb.

"I am vegetarian," he says, passing it to Eliza.

"So am I," Ruby says, not knowing what vegetarian means, but knowing she and Walter have something in common. "We have homemade mint jelly," Ruby says, passing it to him.

Walter puts some jelly on his plate. "Have you got any peanut butter?"

Excited, Ruby runs back into the kitchen and returns with the peanut butter and bread.

During dinner Walter tells stories of his adventures as a delivery man, carrying things back and forth from China, crisscross applesauce all around the world.

After dinner, while Walter and Paul are

downstairs, Ruby and Eliza bring a plate of supper to the widow who is still refusing to come out of the shelter. "Let's wait and see what tomorrow brings," she says, as she pulls the hatch shut and locks it from the inside.

"Good night," Ruby and Eliza call from her backyard. "Sleep tight."

Paul and Walter are downstairs looking for the unit; they find several things—any one (or two) of which could be it.

"We had something similar at home," Walter says. "My father called it his wishing machine."

"You mean washing machine?"

"Wishing machine," Walter says slowly, carefully enunciating.

"My father called it the unit," Paul says. "Do you know what it's supposed to do?"

"It's a magnet," Walter says. "When they are all turned on, it pulls us closer together."

They turn the units on and leave them on—each has a red light, like the flame of a match, like a beacon glowing.

Mary Grace invites Walter to stay the night and given the oddity of the day Paul decides he'll stay too and then Ruby, not wanting to miss a sleepover, insists that she and Eliza stay as well.

"It's been a long time since I've had a full house," Mary Grace says, happily.

After everyone has gone to bed, Mary Grace goes into the kitchen. Walter finds her there, making tea. "I can't sleep," she says.

"Me three," Walter says. "It is a very exciting time." He takes something from inside his coat. "I wanted to wait until there was privacy, I have mail for you, really for your mother, but at a certain point in time, when she is no more, you become your mother. I am sorry to be so late—it was lost in transit."

He hands her a letter written in Chinese.

"Read it to me," Mary Grace says, pouring two cups of tea.

"It is complicated," Walter says, "and my Chinese is not so good. Do people in English have learning disabilities? In China trouble reading is very big problem,

too many characters. Anyway, your father writes to say that in America he is like a forgotten ghost — no more Chinese. He went home to China, but when he got there, he was no more Chinese in China either. His mother wants him to stay, she finds him a wife but the night before the wedding he runs away. He runs, he walks, he swims back to America. He arrives as traveling salesman — selling knicker nackers floor to floor. He can never go home again. He met your mother in Florida. He loves her very much. He wishes he could marry her. In the letter he mentions the kindness — that is why I come today to return the kindness and to deliver the mail."

Walter excuses himself from the table and opens the front door; a loud hot wind blows through the house, lifting the letter out of Mary Grace's hand. She grabs it mid-air, folds it and tucks it into her apron pocket. Walter returns carrying a box wrapped in very old paper, tied with string so worn that it is crumbling.

"This is a box he want to send to your mother. It is a wedding dress."

Mary Grace opens the box. "I am ready for something new," she says. "It is time for a fresh skin." The dress, almost a hundred years old, is long red silk and remains in perfect condition. Mary Grace holds it to her heart.

"Time for bed," Walter says, raising his teacup. "Tomorrow more will come."

In the morning they come. Yin and Yang, the gymnasts, are already there, warming up on the front lawn, doing back flips and cartwheels when Mary Grace opens the door in her robe to get the newspaper.

"Mother may I?" they ask.

"Yes you may," she says.

And they begin to perform a ritual dance on the lawn while singing a Chinese version of "Singing in the Rain."

As they dance through the front door, they take off their black coats and turn them inside out, revealing the white underside, like a lab coat. They take old pieces of paper that look like parts of a puzzle, a map or a code, from their pockets and put them on the kitchen table where Walter works with a roll of Scotch Magic tape to put it all together. And then the Chinese strong men move through the house assembling the boxes, suitcases, trunks, preparing to unpack.

Ruby takes a box of Cheerios across the street to the widow's secret hideout and knocks on the door. "Ollie Ollie oxen free," she says. "Come out, come out, wherever you are. If there ever was a time, this is the time. The moment is now."

Voltaire pulls up just after nine. "I have to shake your hand," he says to Walter. "You have loomed large in my consciousness. I'm not just here by accident. I am the beautiful boy, bastard son of Pierre Teilhard de Chardin, descendant of Voltaire. My mother knew Mr. Roger Giroux; she knew Mr. and Mrs. Stanley Hyman of Bennington, Vermont. She knew everybody who was anybody. In fact I have some of Shirley Jackson's ashes in the back of the car — a gift from Chuck Palahniuk, who was given them by a Jackson/Hyman daughter. I grew up on Park Avenue and in Poughkeepsie and have been waiting for this moment my whole life. I feel as though I have known all of you forever. This is it!" he shouts. "This is the Omega Point!" He kisses Walter square on the lips, "Everything that rises must converge!" he exclaims.

"Could someone please explain?" Paul and Eliza demand.

"Sit," Walter says and they take their places at the kitchen table for a brief history lesson. "In the 1920s and 1930s, the bones of Sinanthropus pekinensis, Homo erectus pekinensis, were discovered on Dragon Bone Hill by a group of anthropologists, among them Mr. Walter Granger of Vermont and Pierre Teilhard de Chardin, geopaleontologist and Jesuit priest from France. In 1937 Japan invaded China."

"I told you there was a link," Paul says to Eliza.

"People worried what would happen if Japan and America were at war — and so the bones were crated and were about to be shipped to America when Japan attacked Pearl Harbor. In all the upset, the bones vanished. Some said they sank on a ship, some thought

they were taken by train, no one person knew what had happened, and no one has seen them since. Slowly but surely they were making their way to America, here to your attic in North Adams, Massachusetts, the safest place in the world."

"Why our house?"

"It is not about your house, it is because you are Chinese, a descendent of Lue Gim Gong," Walter says, as though it is obvious. "The boxes came slowly over time to be discreet, but now it is time for them to be revealed. These are bones of Peking man. We thank you for holding our history."

They cover the dining room table with a beautiful red cloth and a preliminary exhibit is laid out — the basket of fruit in the center.

News spreads fast. "That is my job," Voltaire says. "As the writer among us, I made a press release." Television satellite trucks are pulling up, NBC, CNN, local affiliates. The widow comes out of the storm shelter, wondering what all the fuss is about — she thinks it is all about her.

"Isn't anyone entitled to a private life anymore?" she asks Ruby.

Voltaire, tooth fairy, space cowboy, author and PR man is working the front door like a bouncer, a carnival barker, a first docent at the museum of man. "Come one come all, step right up and see what's inside. This is history in the making, the missing returned, the secret revealed, the history of man made whole."

At noon, around the world, all the "units," the wishing machines, the peacemakers, the what-cha-ma-call-its are turned on. Giant rainbows crisscross the sky in a show of light, sound and magnetism. In the house, in every village and town, appliances, cars, computers, iPhones and BlackBerries feel the tug. They slip off the wall and edge slightly forward, coming together, leaning in, ready for more.

Mary Grace is upstairs, putting on her mother's wedding dress. She is transformed from New England matriarch, Norman Rockwell grandmother, to a sagacious Chinese beauty. She takes the bright red lipstick that was among her mother's effects and paints a "cupid's bow" onto her mouth. Leading with a long red ribbon, Ruby does a dance down the stairs out the back door, twirling the ribbon like an honor guard, maid of honor. Mary Grace silently descends and goes out the back door to her apple tree. She stands arms open, extended, waiting until she catches the light. And then slowly she is lifted.

Sensing that something is happening Paul and Eliza ask, "where is she?" and are ushered out the back door.

"How did she get there?" the widow from across the street asks.

"I can assure you she didn't climb," Eliza says. "She can't even get up a step ladder."

"She was lifted," someone says.

"Mama, are you all right?" Eliza calls out.

"I'm fine," Mary Grace says; she is after all a woman of great faith. The feeling for her is one of elongation, stretching. If she pulls back, it is uncomfortable and she wonders why she is resisting, why she is trying to stay on the ground.

"Mama, no," Eliza calls out.

"Don't worry," Ruby says, comforting her mother, "You are not alone, you have me."

As Mary Grace rises up it begins to snow; heavy thick flakes, more like shavings, or the debris of something that exploded far, far away begin to fall to the ground. The flakes melt onto whatever they touch, coating it with something like wax, fixing it in time and space.

Without a word, Mary Grace rises further still, surrendering, ascending until she is out of sight.

AUTHORS NOTE: There are an enormous number of facts/coincidences in this story that are reality based—Lue Gim Gong—the Citrus Wizard was a real person, one of the few Chinese who came to North Adams during the shoe factory strike in 1870 and who remained—he did travel with the Burlingame family to Florida and so on (he did not as far as I know have a child with anyone). Flannery O'Connor's "Everything That Rises Must Converge" (*title and influence) comes from the very real French philosopher and Jesuit priest Pierre Teilhard de Chardin—who coined the phrase Omega Point to describe a maximum level of complexity and consciousness towards which the universe appears to be evolving. Pierre Teilhard was among the discoverers of the bones of Peking man—and after saying he wanted to die on Easter Sunday—did in fact die on Easter Sunday in New York on April 10, 1955. Pierre Teilhard exchanged letters with the very real (and not often written about) Walter Granger of Vermont a key anthropologist and discoverer of Peking Man. Importantly, the bones of Peking Man were enroute to the US when Pearl Harbor was bombed and they were lost—and have NEVER been found.

A.M. Homes is the author of numerous books, most recently the memoir The Mistress's Daughter *and the novel,* This Book Will Save Your Life. *She writes frequently on the arts for numerous magazines including* The New Yorker, Vanity Fair, Frieze *and* Artforum. *Her great-grandparents had a dairy farm in North Adams, where her grandmother, nine great aunts and uncles lived for many many years.*

Checklist

All dimensions h × w × d in inches unless otherwise noted. All works © Petah Coyne; courtesy Petah Coyne & Galerie Lelong unless otherwise noted

Sculptures

Untitled #638 (Whirlwind), 1989. Chicken-wire fencing, steel, cotton muslin, Celluclay, wire, cable, paint, black sand from pig-iron casting, rope, polymer. 113 × 65 ½ × 53 ½ (287 × 166.4 × 135.9 cm)

Untitled #672 (David), 1989–91. Chicken-wire fencing, horsing-fence wire, tomato-fence wire, steel, wire, cable, paint, black sand from pig-iron casting, rope, polymer. 102 × 61 × 56 (259.1 × 154.9 × 142.2 cm)

Untitled #670 (Black Heart), 1990. Chicken-wire fencing, clay, mud, black sand from pig-iron casting, steel, wire, pig iron, polymer, resin 87 × 59 × 62 (221 × 149.9 × 157.5 cm)

Untitled #669 (Fallen), 1990–91. Chicken-wire fencing, horsing-fence wire, tomato-fence wire, steel, wire, cable, paint, black sand from pig-iron casting, rope, polymer. 50 × 72 × 49 (127 × 182.9 × 124.5 cm)

Untitled #720 (Eguchi's Ghost), 1992/2007. Stainless-steel wire, brass wire, phosphorus wire, steel wire, chicken-wire fencing, cable, cable nuts, PVC pipe, chiffon, thread, Velcro, jaw-to-jaw shackles. 120 × 68 × 75 (304.8 × 172.7 × 190.5 cm)

Untitled #1205 (Virgil), 1997–2008. Silk flowers, taxidermy animals, fabricated tree branches, fabricated curly willow, feathers, silk/rayon velvet, thread, specially formulated wax, cable, cable nuts, fabricated steel, acrylic paint, black spray paint, pearl-headed hat pins, wood, plywood, vinyl, chicken-wire fencing, felt, pigment, wire, metal hardware. 68 × 97 × 115 (172.7 × 246.4 × 292.1 cm)

Untitled #1093 (Buddha Boy), 2001–03. Statuary with human and horse hair, ribbons, pigment, specially formulated wax, black spray paint, fabricated rubber, wired tree branches, curly willow, chicken-wire fencing, wire, acrylic primer, silk flowers, bows, acetate, ribbons, feathers, plywood, metal hardware, pearl-headed hat pins, tassels. 52 × 50 × 48 (132.1 × 127 × 121.9 cm)

Untitled #1180 (Beatrice), 2003–08. Cast-wax statuary, taxidermy animals, taxidermy birds, silk flowers, silk/rayon velvet, specially formulated wax, felt, tree branches, tree bark, driftwood, cable, cable nuts, acrylic paint, black spray paint, chicken wire fencing, metal hardware, felt, pearl-headed hat pins, pigment, thread, wire, plywood, wood, vinyl. 136 × 109 × 121 (345.4 × 276.9 × 307.3 cm)

Untitled #1181 (Dante's Daphne), 2004–06. Fabricated tree branches, chicken-wire fencing, rayon and silk flowers, berries, feathers, specially formulated wax, silk/rayon velvet, nylon thread, wire, cable, shackles, pearl-headed hat pins, black spray paint, metal tubing, metal wire, artificial birds, cable bolts. 62 × 70 × 101 (157.5 × 177.8 × 256.5 cm)

Untitled #1203 (Camel's Back), 2005–07. Rayon and silk flowers, artificial birds, specially formulated wax, nylon thread, fabricated tree branches, feathers, pearl-headed hat pins, black spray paint, chicken-wire fencing, wire, cable, shackles, metal plate, metal tubing, cable bolts. 98 × 80 × 31 (248.9 × 203.2 × 78.7 cm). Collection of Galerie Lelong, New York

Untitled #1175 (La Notte), 2003–08. Taxidermy ducks and quail, chandelier, candles, silk flowers, chandelier wax, black spray paint, pearl-headed hat pins, black wire, quick-link shackles, cable, cable nuts, chain, silk/rayon velvet, felt, thread, Velcro. 61 ¼ × 47 × 59 (155.6 × 119.4 × 149.9 cm)

Untitled # 1176 (Elisabeth-Elizabeth), 2007–10. Taxidermy birds, chandelier, candles, silk flowers, chandelier wax, black spray paint, pearl-headed hat pins, black wire, quick-link shackles, cable, cable nuts, chain, silk/rayon velvet, felt, thread, Velcro. 70 ½ × 62 ½ × 78 ¾ (179.1 × 158.8 × 200 cm)

Untitled #1234 (Tom's Twin), 2007–08. Silk flowers, silk/rayon velvet, feathers, wooden cradle, chandelier, taxidermy birds, candles, specially formulated wax, acrylic paint, black spray paint, chicken-wire fencing, metal hardware, plywood, felt, quick-link shackles, pearl-headed hat pins, pigment, thread, chain, jaw-to-jaw swivels, Velcro, wire, vinyl, wood, cable, cable nuts. Main body of sculpture: 26 × 182 × 99 (66 × 462.3 × 251.5 cm). Hanging element: 56 × 39 × 39 (142.2 × 99.1 × 99.1 cm)

Untitled #1240 (Black Cloud), 2007–08. Taxidermy birds, silk flowers, silk/rayon velvet, plaster statuary, feathers, specially formulated wax, cable, cable nuts, acrylic paint, black spray paint, plaster, chicken-wire fencing, metal hardware, felt, pearl-headed hat pins, pigment, thread, wire, plywood, wood, vinyl. 74 × 104 × 174 (188 × 264.2 × 442 cm)

Untitled #1274 (Death in Venice), 2003–08. Chandelier, ripped silk organza, hand-painted silk flowers with wax, wire, silk/rayon velvet, cable, cable nuts, Velcro, thread, quick-link shackle, jaw-to-jaw swivel. 50 × 33 × 31 (127 × 83.8 × 78.7 cm)

Untitled #1281 (Canto VIII), 2008. Taxidermy turkey, silk flowers, silk/rayon velvet, specially formulated wax, cable, cable nuts, steel, black spray paint, pearl-headed hat pins, pigment, felt, wire, metal hardware, chicken-wire fencing, thread. 63 ½ × 59 × 15 ½ (161.3 × 149.9 × 39.4 cm)

Untitled #1292 (Scarlett), 2008–09. Taxidermy bird, silk/rayon velvet, silk flowers, specially formulated wax, pigment, chicken-wire fencing, feathers, cable, cable clamps, pearl-headed hat pins, wire, thread, metal hardware, black enamel spray paint, Ook hooks, eye-hook turnbuckles. 54 ¼ × 51 ¼ × 24 (137.8 × 130.2 × 70 cm)

Untitled # 1336 (Scalapino Nu Shu), 2009–10. Apple tree, taxidermy Black Melanistic Pheasants, taxidermy Blue India Peacocks, taxidermy Black-Shouldered Peacocks, taxidermy Spalding Peacocks, black sand from pig-iron casting, Acrylex 234, black paint, cement, chicken-wire fencing, wood, gravel, sisal, staging rope, cotton rope, insulated foam sealant, pipe, epoxy, threaded rod, wire, screws, jaw-to-jaw swivels. 158 × 264 × 288 (401.3 × 670.6 × 731.5 cm)

Photographs

Untitled #735 (Monks II, Monk Series), 1992. Silver gelatin print. 33 × 49 (83.8 × 124.5 cm). Edition 4 of 5 . Collection of Weil, Gotshal, Manges, LLP, New York

Untitled #738 (Monks I, Monk Series), 1992. Silver gelatin print. 33 × 49 (83.8 × 124.5 cm). Edition AP 1 of 3

Untitled #809 (Sun Rising, Piñata Series), 1994. Silver gelatin print. 49 × 33 (124.5 × 83.8 cm). Edition HC 1 of 2

Untitled #938 (Fourth of July Portfolio), 1995. Nine silver gelatin prints. 3 × 3 each (7.6 × 7.6 cm). Edition 19 of 20. Collection of Tom and Leslie Maheras, New York

Untitled #844 (Haley, Haley & Degas Series), 1996. Silver gelatin print. 40 × 60 (101.6 × 152.4 cm). Edition 1 of 7. Collection of Joseph Baio, New York

Untitled #883 (Tear Drop Monks, Monk Series), 1997. Silver gelatin print. 40 × 60 (101.6 × 152.4 cm). Edition 4 of 7

Untitled #885 (Saucer Baby, Carolyn Rose Series), 1997. Silver gelatin print. 49 × 32 ¾ (124.5 × 83.2 cm). Edition 2 of 7

Untitled #886 (Two Women Dancing, Conway & Pratt Series), 1997. Silver gelatin print. 23 × 15 (58.4 × 38.1 cm). Edition AP 1 of 3

Untitled #901 (Legs, Carolyn Rose Series), 1997. Silver gelatin print. 60 × 40 (152.4 × 101.6 cm). Edition 2 of 7

Untitled #1007 (Susan's Hem I, Bridal Series), 2001. Silver gelatin print. 60 × 40 (152.4 × 101.6 cm). Edition 1 of 7

Untitled #1009 (Bell Hem, Bridal Series), 2001. Silver gelatin print. 14 × 11 (35.5 × 28 cm). Edition PP1 of 4

Untitled #1010 (Lily Pond Hem, Bridal Series), 2001. Silver gelatin print. 14 × 11 (35.5 × 28 cm). Edition PP1 of 3

Untitled #1012 (Right Corner Portrait with Dress, The Debs Series), 2001. Silver gelatin print. 14 × 11 (35.5 × 28 cm). Edition PP3 of 3

Untitled #1013 (Right Corner Portrait Side View, The Debs Series), 2001. Silver gelatin print. 14 × 11 (35.5 × 28 cm). Edition PP3 of 3

Untitled #1014 (Full Side View, The Debs Series), 2001. Silver gelatin print. 14 × 11 (35.5 × 28 cm). Edition PP1 of 2

Untitled #1015 (Full Dress with String Back, The Debs Series), 2001. Silver gelatin print. 14 × 11 (35.5 × 28 cm). Edition PP1 of 2

Untitled #1016 (Full Toe Dancing, The Debs Series), 2001. Silver gelatin print. 14 × 11 (35.5 × 28 cm). Edition PP3 of 4

Untitled #1017 (Raphaelite Feet Dancing, The Debs Series), 2001. Silver gelatin print. 17 ⅛ × 37 ¹¹⁄₁₆ (43.5 × 95.7 cm). Edition 5 of 7

Untitled #1018 (One Foot with Hem, The Debs Series), 2001. Silver gelatin print. 14 × 11 (35.5 × 28 cm). Edition PP1 of 2

Untitled #1019 (Three Women Dancing: Can-Can, The Debs Series), 2001. Silver gelatin print. 14 × 11 (35.5 × 28 cm). Edition PP3 of 3

Untitled #1023 (Clara Series), 2001. Silver gelatin print. 14 × 11 (35.5 × 28 cm). Edition PP1 of 2

Untitled #1024 (Propeller Fan, Clara Series), 2001. Silver gelatin print. 14 × 11 (35.5 × 28 cm). Edition PP1 of 2

Untitled #1025 (Clara Series), 2001. Silver gelatin print. 14 × 11 (35.5 × 28 cm). Edition PP1 of 3

Untitled #1026 (Clara Series), 2001. Silver gelatin print. 14 × 11 (35.5 × 28 cm). Edition PP1 of 2

Untitled #1027 (Clara Series), 2001. Silver gelatin print. 14 × 11 (35.5 × 28 cm). Edition PP1 of 3

Untitled #1028 (Clara Haley, Clara Series), 2001. Silver gelatin print. 14 × 11 (35.5 × 28 cm). Edition PP1 of 3

Untitled #1029 (Feet, Clara Series), 2001. Silver gelatin print. 14 × 11 (35.5 × 28 cm). Edition PP1 of 2

Untitled #1030 (Clara Series), 2001. Silver gelatin print. 14 × 11 (35.5 × 28 cm). Edition PP1

Untitled #1032 (Clara Series), 2001. Silver gelatin print. 14 × 11 (35.5 × 28 cm). Edition PP1 of 1

Untitled #1033 (Clara Series), 2001. Silver gelatin print. 14 × 11 (35.5 × 28 cm). Edition PP1

Untitled #1036 (Velazquez Bride, Bridal Series), 2001. Silver gelatin print. 14 × 11 (35.5 × 28 cm). Edition PP1 of 4

Untitled #1037 (Back Buttons, Bridal Series), 2001. Silver gelatin print. 14 × 11 (35.5 × 28 cm). Edition PP1 of 2

Untitled #1038 (Drapery Dress, Bridal Series), 2001. Silver gelatin print. 14 × 11 (35.5 × 28 cm). Edition 3 of 7

Untitled #1039 (Bridal Series), 2001. Silver gelatin print. 60 × 40 (152.4 × 101.6 cm). Edition 2 of 7

Untitled #1040 (One Leg Hanging, Bridal Series), 2001. Silver gelatin print. 14 × 11 (35.5 × 28 cm). Edition PP1 of 3

Untitled #1041 (Full Fitted Dress, Bridal Series), 2001. Silver gelatin print. 14 × 11 (35.5 × 28 cm). Edition PP1 of 3

Untitled #1043 (Full Frame Skirt, Bridal Series), 2001. Silver gelatin print. 40 × 30 (101.6 × 76.2 cm). Edition 2 of 7. Private collection, New York

Untitled #1046 (Hanging White/ Hanging Black, The Debs Series), 2001 . Silver gelatin print . 11 × 14 (28 × 35.5 cm). Edition PP1

Untitled #1047 (Shadows, The Debs Series), 2001 . Silver gelatin print . 11 × 14 (28 × 35.5 cm). Edition PP1 of 2

Untitled #1048 (Black Poodle, The Debs Series), 2001 . Silver gelatin print . 14 × 11 (35.5 × 28 cm). Edition PP1 of 2

Untitled #1050 (Two Figures, The Debs Series), 2001 . Silver gelatin print . 14 × 11 (35.5 × 28 cm). Edition PP1

Untitled #1034 (Tip-Toe Through Bow/Lily Pond, The Debs Series), 2002. Silver gelatin print. 14 × 11 (35.5 × 28 cm). Edition 4 of 7

Petah Coyne

Born 1953, Oklahoma City, Oklahoma; lives and works in New York

1973–1977
Art Academy of Cincinnati, Ohio

1972–1973
Kent State University, Ohio

Selected Solo Exhibitions

2010
Everything That Rises Must Converge, MASS MoCA, North Adams, Massachusetts

2008
Petah Coyne: Vermilion Fog, Galerie Lelong, New York

2005
Petah Coyne: Above and Beneath the Skin, Organized by the Albright-Knox Art Gallery, Buffalo, New York. Exhibited at Sculpture Center, Long Island City, New York; Chicago Cultural Center, Chicago, Illinois; Kemper Museum of Contemporary Art, Kansas City, Missouri; Scottsdale Museum of Contemporary Art, Scottsdale, Arizona; and Albright-Knox Art Gallery, Buffalo, New York

Petah Coyne: Above and Beneath the Skin, Galerie Lelong, New York

2004
Petah Coyne: Hairworks, Cincinnati Art Museum, Ohio

Paris Blue — New Collection, Joslyn Art Museum, Omaha, Nebraska

2002
Petah Coyne: Sculpture and Photography, Bentley Gallery, Scottsdale, Arizona

2001
Petah Coyne: Fairy Tales, Frist Center for the Visual Arts, Nashville, Tennessee

White Rain, Galerie Lelong, New York

Spring Snow, Julie Saul Gallery, New York

Petah Coyne, Byron C. Cohen Gallery for Contemporary Art, Kansas City, Missouri

Petah Coyne: Fairy Tales, Sculpture and Related Photographs, Wright State University Art Galleries, Dayton, Ohio

1999
Petah Coyne: Fairy Tales, Butler Gallery, Kilkenny Castle, Ireland

1998
Fairy Tales, Galerie Lelong, New York

Monastic Sightings: Buddhists on the Move, Photography Gallery, Fine Arts Center Galleries, University of Rhode Island, Kingston

black/white/black, Corcoran Gallery of Art, Washington, D.C. Traveled to High Museum of Art, Atlanta, Georgia

Petah Coyne: Photographs, Laurence Miller Gallery, New York. Traveled to Weatherspoon Art Gallery, University of North Carolina, Greensboro

1996
Photographs, Laurence Miller Gallery, New York

1994
Petah Coyne: Recent Sculpture, Jack Shainman Gallery, New York

1992
Petah Coyne, Cleveland Center for Contemporary Art, Ohio. Traveled to Tyler Gallery, Tyler School of Art, Temple University, Philadelphia, Pennsylvania; Museum of Art, Olin Art Center, Bates College, Lewiston, Maine; Center for Contemporary Arts, Santa Fe, New Mexico

1991
Petah Coyne: Recent Sculpture, Diane Brown Gallery, New York

Petah Coyne: Recent Work, Jack Shainman Gallery, New York

Installation by Petah Coyne, Art Gallery, Southeastern Massachusetts University, North Dartmouth

1989
Untitled Installation: A Grand Lobby Project, Brooklyn Museum, New York

Recent Sculpture, Jack Shainman Gallery, New York

1988
Petah Coyne: 1987 Augustus Saint-Gaudens Fellow, Picture Gallery, Saint-Gaudens National Historic Site, Cornish, New Hampshire

1987
Petah Coyne: Artist in Residence 1987, Sculpture Center, New York

Special Projects, P.S.1, The Institute for Art and Urban Resources, Long Island City, New York

Selected Group Exhibitions

2010
Until Now: Collecting the New (1960–2010), Minneapolis Institute of Arts, Minnesota

Exposure: Photos from the Vault, Denver Art Museum, Colorado

Pleasure Point: Celebrating 25 Years of Contemporary Collectors, Museum of Contemporary Art San Diego, La Jolla, California

185th Annual: An Invitational Exhibition of Contemporary Art, National Academy Museum & School of Fine Arts, New York

Desire, The Blanton Museum of Art, The University of Texas at Austin

The Language of Flowers, CRG Gallery, New York

2009
Trail Blazers in the 21st Century: Contemporary Prints and Photographs Published by Exit Art, Jane Voorhees Zimmerli Art Museum, New Brunswick, New Jersey

Reflection, Refraction, Reconfiguration, University Art Museum, Colorado State University, Fort Collins

2008
Roots & Ties II, Untitled [ArtSpace], Oklahoma City, Oklahoma

Time/Frame, Spencer Museum of Art, University of Kansas, Lawrence

Selections from the Museum's Permanent Collection, Taubman Museum of Art, Roanoke, Virginia

21: Contemporary Art at the Brooklyn Museum, Brooklyn Museum, New York

Damaged Romanticism: A Mirror of Modern Emotion, Blaffer Gallery, University of Houston. Traveled to Grey Art Gallery, New York University; The Parrish Art Museum, Southampton, New York

2007
Contemporary and Cutting Edge: Pleasures of Collecting, Part III, Bruce Museum, Greenwich, Connecticut

New at the Nasher, Nasher Museum of Art, Duke University, Durham, North Carolina

Passion Complex: Selected Works from the Albright-Knox Art Gallery, 21st Century Museum of Contemporary Art, Kanazawa, Japan

Shadow, Galerie Lelong, New York

Uncontained, Whitney Museum of American Art, New York

Back to the Future: Contemporary Art from the Mead Collection, Mead Art Museum, Amherst College, Massachusetts

2006
Material Actions, Museum of Contemporary Art San Diego, California

ARS 06: Sense of the Real, Museum of Contemporary Art Kiasma, Helsinki, Finland

3D—An Exhibition of Contemporary Sculpture, Carl Solway Gallery, Cincinnati, Ohio

Art on the Edge: Modern & Contemporary Art from the Permanent Collection, Joslyn Art Museum, Omaha, Nebraska

Waxworks, Silvermine Guild Arts Center, New Canaan, Connecticut

In Focus: 75 Years of Collecting American Photography, Addison Gallery of American Art, Andover, Massachusetts

2005
The Forest: Politics, Poetics and Practice, Nasher Museum of Art, Duke University, Durham, North Carolina

Neo-Baroque!, Byblos Art Gallery, Verona, Italy

Nine Contemporary Sculptors: Fellows of the Saint-Gaudens Memorial, UBS Art Gallery, New York

Steven Scott Collects: Donations and Promised Gifts to the Permanent Collection, National Museum of Women in the Arts, Washington, D.C.

2004
American Art: Selections from the Permanent Collection 1900–1960, Weatherspoon Art Museum, Greensboro, North Carolina

Ten, Byron C. Cohen Gallery for Contemporary Art, Kansas City, Missouri

Bodily Space: New Obsessions in Figurative Sculpture, Albright-Knox Art Gallery, Buffalo, New York

Revelation: A Fresh Look at Contemporary Collections, The Mint Museum, Charlotte, North Carolina

Behind Closed Doors, Katonah Museum of Art, New York

The Print Show, Exit Art, New York

Birdspace: A Post-Audubon Artists Aviary, Contemporary Arts Center, New Orleans, Louisiana. Traveled to Norton Museum of Art, West Palm Beach, Florida; Hudson River Museum, Yonkers, New York

2003
Materials, Metaphors, Narratives: Work by Six Contemporary Artists, Albright-Knox Art Gallery, Buffalo, New York

Visions and Revisions: Art on Paper Since 1960, Museum of Fine Arts, Boston

Cold Comfort, Memphis College of Art, Tennessee

2002
Petah Coyne/Ann Hamilton, Des Moines Art Center, Iowa

Shift, Galerie Lelong, New York

Into the Woods, Julie Saul Gallery, New York

Flat Not Flat: Four Sculptors Confront the Wall, Judy Ann Goldman Fine Art, Boston

Eve and the Snake, Kunstverein Bad Salzdetfurth e.V., Bodenburg, Germany

Feminism and Art: Selections from the Permanent Collection, National Museum of Women in the Arts, Washington, D.C

What's Hot and New in 2002: A Print and Photography Exhibition and Sale, Katonah Museum of Art, New York

Time Distance Memory, Laurence Miller Gallery, New York

2001
Artists Take On Detroit: Projects for the Tricentennial, Detroit Institute of Arts, Michigan

Lateral Thinking: Art of the 1990s, Museum of Contemporary Art, San Diego, La Jolla, California. Traveled to Colorado Springs Fine Arts Center, Colorado; Hood Museum of Art, Dartmouth College, Hanover, New Hampshire; Dayton Art Institute, Ohio

2000
Snapshot: An Exhibition of 1,000 Artists, Contemporary Museum, Baltimore, Maryland

SCULPTography, Galerie Lelong, New York

The Glen Dimplex Artists Award 2000, Irish Museum of Modern Art, Dublin

Whitney Biennial 2000, Whitney Museum of American Art, New York

Muscle: Power of the View, Boulder Museum of Contemporary Art, Colorado

The End: An Independent Vision of Contemporary Culture, 1982–2000, Exit Art, New York

Faith: The Impact of Judeo-Christian Religion on Art at the Millennium, The Aldrich Museum of Contemporary Art, Ridgefield, Connecticut

Rapture, Bakalar and Huntington Galleries, Massachusetts College of Art, Boston

Object Lessons: Selections from the Robert J. Shiffler Foundation, Columbus Museum of Art, Ohio

1999
Photographs by Painters, Photographers, Sculptors, Lennon, Weinberg, Inc., New York

Millennium Messages, Heckscher Museum of Art, Huntington, New York. Traveled to Tufts University Gallery, Medford, Massachusetts; Everson Museum of Art, Syracuse, New York; Miami University Art Museum, Oxford, Ohio

Best of Season: Selected Work from the 1998–1999 Manhattan Exhibition Season, The Aldrich Museum of Contemporary Art, Ridgefield, Connecticut

Surroundings: Responses to the American Landscape, Selections from the Permanent Collection of the Whitney Museum of American Art, San Jose Museum of Art, California

Drawing in the Present Tense, Aronson and Main Galleries, Parsons School of Design, New York. Traveled to Julian Akus Gallery, Eastern Connecticut State University, Willimantic; North Dakota Museum of Art, Grand Forks; Illinois State University, Normal

Souvenirs/Documents: 20 years, P.S. 122, New York

Domestic Pleasures, Galerie Lelong, New York

Permanent Collection, The Detroit Institute of Arts, Michigan

Artists in Purgatory, Purgatory Pie Press and Collaborators, Long Island University, Salena Gallery, Long Island, New York

26 Sculptors in Their Environments, Rockland Center for the Arts, West Nyack, New York

1998
Coming Off the Wall, Susquehanna Art Museum, Harrisburg, Pennsylvania

Connections & Contradictions: Modern and Contemporary Art from Atlanta Collections, Michael C. Carlos Museum, Emory University, Atlanta

The Human Habit, William King Regional Arts Center, Abingdon, Virginia

Selections from the Permanent Collection, Museum of Contemporary Art San Diego, La Jolla, California

Masters of the Masters: MFA Faculty of the School of Visual Arts, New York 1983–1998, Butler Institute of American Art, Youngstown, Ohio

House of Wax, The Contemporary Arts Center, Cincinnati, Ohio

Sculptors and Their Environments, Pratt Institute Manhattan Gallery, New York. Traveled to Rubelle & Norman Schafler Gallery, Pratt Institute, Brooklyn, New York

Preview, Review, Galerie Lelong, New York

The Tip of the Iceberg, Art Resources, New York

1997
Eye of the Beholder: Photographs from the Avon Collection, International Center of Photography, New York

Post Construction, Vakin Schwartz, Atlanta, Georgia

Selections from the Collections, The Museum of Modern Art, New York

Biennial Exhibition of Public Art, Neuberger Museum of Art, Purchase College, State University of New York, Purchase

Permanent collection, Museum of Contemporary Art, San Diego, California

1996
Simple Gifts: A Selection of Gifts to the Collection from Lily Auchincloss, The Museum of Modern Art, New York

Partners in Printmaking: Works from Solo Impression Inc., National Museum of Women in the Arts, Washington, D.C.

Transforming the Social Order, Temple Gallery, Tyler School of Art, Temple University, Philadelphia, Pennsylvania

Inside, California Center for the Arts, Escondido, California

Graphics from Solo Impression Inc., Members' Gallery, Albright-Knox Art Gallery, Buffalo, New York

Square Bubbles, Mandeville Gallery, Union College, Schenectady, New York

1995
The Invisible Force: Nomadism as Art Practice, Polk Museum of Art, Lakeland, Florida

Inside/Outside: From Sculpture to Photography, Laurence Miller Gallery, New York

Essence and Persuasion: The Power of Black and White, Anderson Gallery, University of Buffalo, State University of New York, Buffalo

Other Choices/Other Voices, Islip Art Museum, East Islip, New York

Object Lessons: Feminine Dialogues with the Surreal, Massachusetts College of Art, Huntington Gallery, Boston

1994
Digressions, Caren Golden Fine Art, New York

Prints from Solo Impression Inc., The College of Wooster Art Museum, Ohio

Fabricated Nature, Boise Art Museum, Idaho. Traveled to University of Wyoming Art Museum, Laramie; Virginia Beach Center for the Arts, Virginia

The Garden of Sculptural Delights, Exit Art /The First World, New York

In the Lineage of Eva Hesse, The Aldrich Museum of Contemporary Art, Ridgefield, Connecticut

1993
Drawings: 30th Anniversary Exhibition, Leo Castelli Gallery, New York

25 Years, A Retrospective, Cleveland Center for Contemporary Art, Ohio

Monumental Propaganda, Courtyard Gallery, World Financial Center, New York. Traveled to International Gallery, Smithsonian Institution, Washington, D.C.; Dunlop Art Gallery, Regina Public Library, Saskatchewan, Canada; Muckenthaler Art Center, Fullerton, California; Bass Museum of Art, Miami Beach, Florida; Kemper Museum of Contemporary Art, Kansas City, Missouri; Helsinki City Art Museum, Finland; Lenin Museum, Tampere, Finland; Uppsala Konstmuseum, Sweden; Contemporary Art Center, Copenhagen; Kennesaw State University, Georgia; Institute of Contemporary Art, Moscow; Tallinn, Estonia; Lubiljana, Slovenia. Organized by Independent Curators International

Forest of Visions, Knoxville Museum of Art, Tennessee. Traveled to Cheekwood Museum of Art, Nashville, Tennessee; Samuel P. Harn Museum of Art, Gainesville, Florida

Testwall, TZ'Art & Co., New York

Artist & Homeless Collaborative Project, Visual Arts Gallery, Henry Street Settlement, New York

1992
Miauhaus, Thread Waxing Space, New York

Beauty and the Beast, Neuberger Museum of Art, Purchase College, State University of New York, Purchase. Traveled to Artists Space, New York

Natural Forces/Human Observations, Charlotte Crosby Kemper Gallery, Kansas City Art Institute, Missouri

1991
Contemporary Collectors, Museum of Contemporary Art San Diego, La Jolla, California

Vital Forces: Nature in Contemporary Abstraction, Heckscher Museum, Huntington, New York

10th Annual Awards in the Visual Arts, Hirshhorn Museum and Sculpture Garden, Smithsonian Institute, Washington D.C. Traveled to Albuquerque Museum of Art, History and Science, New Mexico; Toledo Museum of Art, Ohio; The BMW Gallery, New York

1990
Visions 90, in Art Contemporain 1990, La galerie d'art lavalin in collaboration with Centre international d'art contemporain de Montreal, Quebec, Canada

Detritus: Transformation and Re-Construction, Jack Tilton Gallery, New York

The (Un) Making of Nature, a two-part exhibition—Whitney Museum of American Art at Phillip Morris, New York, and Whitney Museum of American Art Downtown at Federal Reserve Plaza, New York. Traveled to Whitney Museum of American Art at Fairfield County, Stamford, Connecticut

American Academy and Institute of Arts and Letters Invitational Exhibition of Painting and Sculpture, American Academy and Institute of Arts and Letters, New York

Visiting Artist Exhibition, Edwin
W. Zoller Gallery, School of Visual
Arts, Pennsylvania State University,
University Park

1989
*Terra Firma: Land and Landscape in
Art of the 1980s*, Wallach Art Gallery,
Columbia University, New York

*Lines of Vision: Drawings by
Contemporary Women*, Hillwood
Art Gallery, C.W. Post Campus, Long
Island University, Brookville, New
York. Traveled to Blum Helman
Gallery, Warehouse Space, New
York; Murray State University,
Murray, Kentucky; Grand Rapids Art
Museum, Michigan; University Art
Gallery, University of North Texas,
Denton; Richard F. Brush Gallery,
St. Lawrence University, Canton,
New York; University of Oklahoma,
Museum of Art, Norman

The Emerging Figure, Norton
Gallery of Art, West Palm Beach,
Florida. Traveled to The Edith C.
Blum Art Institute, Milton and Sally
Avery Arts Center, Bard College,
Annandale-On-Hudson, New York

1988
David and Goliath, Jack Shainman
Gallery, New York

Shape Shifting, Cavin-Morris,
New York

*Life Forms: Contemporary
Organic Sculpture*, Freedman
Gallery, Albright College, Reading,
Pennsylvania

*Primitive Works for Public
Spaces: Drawings, Maquettes and
Documentation for Unrealized
Public Artworks*, RC Erpf Gallery,
New York

Kindred Spirits, George Ciscle
Gallery, Baltimore, Maryland

*Strike: Nature, Abstraction,
Aggression*, Valencia Community
College, East Campus, Orlando,
Florida

*Nomadic Visions: Recent Works
by Six New York Sculptors*, Art
Gallery, Southeastern Massachusetts
University, North Dartmouth

1987
Elements: Five Installations,
Whitney Museum of American Art at
Equitable Center, New York

Sculpture, Proctor Art Center, Bard
College, Annandale-On-Hudson,
New York

*O.I.A. Tenth Anniversary Outdoor
Sculpture Exhibition*, Snug Harbor
Cultural Center, Staten Island,
New York

Personal Poetics, Sala 1, Rome, Italy

*Alternative Supports: Contemporary
Sculpture on the Wall*, David Winton
Bell Gallery, Brown University,
Providence, Rhode Island

Works on Paper, Tomoko Ligouri
Gallery, New York

*Standing Ground: Sculpture by
American Women*, Contemporary
Arts Center, Cincinnati, Ohio

Group Show, Grand Street Gallery,
New York

Blum/Coyne/Fishman, John Slade Ely
House, New Haven, Connecticut

Small Works, Sculpture Center,
New York

Endangered Species, Alternative
Museum, New York

1986
A Contemporary View of Nature, The
Aldrich Museum of Contemporary
Art, Ridgefield, Connecticut

*South Beach III — Outdoor Public
Sculpture*, Organization of
Independent Artists, Staten Island,
New York

*The Figure Abstracted: Intimated
Presences*, Robeson Center Gallery,
Rutgers University, Newark, New
Jersey

Blum/Coyne/Fishman, P.S. 122,
New York

Transformations, Richard Green
Gallery, New York

*Nature Observed: Sculpture,
Painting and Photography by
Contemporary Artists*, Danforth
Museum of Art, Framingham,
Massachusetts

Personal Visions, East Hampton
Center for Contemporary Art,
New York

Benefit Exhibition, East Hampton
Center for Contemporary Art,
New York

The All Natural Disaster Show,
P.S. 39 Longwood Art Project, Bronx,
New York

Bodies and Dreams, White Columns,
New York

Sculpture X Six, Bronx Museum of
the Arts, Satellite Gallery, Hostos
Community College, Bronx, New
York

Group Show, Stokker/Stikker
Gallery, New York

1985
Toy Show, BACA, Brooklyn,
New York

Bayou Show, The Houston Festival,
Texas

Getting Off, Civilian Warfare,
New York

1984
Drawings, Sculpture Center,
New York

Sculpture Chicago '84, Chicago,
Illinois

Holiday Invitational, A.I.R. Gallery,
New York

Body Memories, BACA, Brooklyn,
New York

Outdoor Public Sculpture, Chicago,
Illinois

Group Show, Chicago, Illinois

Mimes and Miniatures, BACA,
Brooklyn, New York

1983
Art on the Beach, Creative Time Inc.,
New York

Awards

CUE Art Foundation, Honoree, New York, 2009
Anonymous Was a Woman, Artist Grant, New York, 2007
Civitella Ranieri Center, Visual Arts Fellow, Umbertide, Italy, 2005
Cincinnati Art Academy, Honorary Doctorate, Cincinnati, Ohio, 2001
Museum of Modern Art, Glen Dimplex Award Finalist, Dublin, Ireland, 2000
Sirus Project, Cobh Fellowship, County Cork, Ireland, 2000
AICA International Association of Art Critics, Exhibition Award, 1999
The Joan Mitchell Foundation, Sculpture Grant, New York, 1998
Acadia Art Program, Northeast Harbor, Maine, 1997
AICA International Association of Art Critics, Exhibition Award, 1995
National Endowment for the Arts, International Exchange, US/Mexico
 Creative Artists' Residency Grant, 1994
Asian Cultural Council, Japan Fellowship, New York, 1992
National Endowment for the Arts, Sculpture Fellowship,
 Washington, D.C., 1990
National Endowment for the Arts, International Exchange Fellowship,
 France, 1990
Southeastern Center for Contemporary Art, Awards in the Visual Arts,
 Winston-Salem, North Carolina, 1990
The Rockefeller Foundation, Bellagio Residency, Italy, 1990
John Simon Guggenheim Memorial Foundation, Fellowship, New York, 1989
Art Matters, Inc., Artist Grant, New York, 1989
New York Foundation for the Arts, Sculpture Fellowship, New York, 1988
Massachusetts Council on the Arts and Humanities, New Works Grant,
 Boston, 1988
Pollock-Krasner Foundation, Inc., Artists Grant, New York, 1987
Augustus Saint-Gaudens Memorial Foundation, Sculpture Fellowship,
 Cornish, New Hampshire, 1987
Artists Space, Committee for the Visual Arts, Inc., New York, 1987
Artists Space, Committee for the Visual Arts, Inc., New York, 1986
Artists Space, Committee for the Visual Arts, Inc., New York, 1984

Public Collections

Addison Gallery of American Art, Phillips Academy, Andover, Massachusetts
Albright-Knox Art Gallery, Buffalo, New York
Art Museum of Western Virginia, Roanoke
Avon Products, Inc., New York
Bell Atlantic, Cincinnati, Ohio
Brooklyn Museum, Brooklyn, New York
Brooklyn Union Gas, Brooklyn, New York
Cincinnati Art Museum, Ohio
Corcoran Gallery of Art, Washington, D.C.
Denver Art Museum, Colorado
Des Moines Art Center, Iowa
Detroit Institute of Arts, Michigan
Solomon R. Guggenheim Museum, New York
High Museum of Art, Atlanta, Georgia
Hirshhorn Museum and Sculpture Garden, Smithsonian Institution, Washington, D.C.
Joslyn Art Museum, Omaha, Nebraska
Kemper Museum of Contemporary Art, Kansas City, Missouri
List Visual Arts Center, Massachusetts Institute of Technology, Cambridge
Mead Art Museum, Amherst College, Massachusetts
Metropolitan Museum of Art, New York
Mint Museum of Art, Charlotte, North Carolina
Morgan Stanley, New York
Museum of Contemporary Art Kiasma, Helsinki, Finland
Museum of Contemporary Art, North Miami, Florida
Museum of Contemporary Art San Diego, California
Museum of Fine Arts, Boston, Massachusetts
Museum of Modern Art, New York
Nasher Museum of Art, Duke University, Durham, North Carolina
National Gallery of Art, Washington, D.C.
National Museum of Women in the Arts, Washington, D.C.
Nelson-Atkins Museum of Art, Kansas City, Missouri
Neuberger & Berman, New York
New School for Social Research, New York
Philadelphia Museum of Art, Pennsylvania
Phoenix Art Museum, Arizona
Progressive Corporation, Cleveland, Ohio
Speed Art Museum, Louisville, Kentucky
Spencer Museum of Art, University of Kansas at Lawrence
Weatherspoon Art Gallery, University of North Carolina, Greensboro
West Collection, SEI, Oaks, Pennsylvania
Whitney Museum of American Art, New York

Bibliography

Monographs

Antonsen, Lasse. *Installation by Petah Coyne* (catalogue). North Dartmouth, MA: Southeastern Massachusetts University Art Gallery, 1991.

Dreishpoon, Douglas. *Petah Coyne: Photographs.* New York: Laurence Miller Gallery, 1996.

Petah Coyne: Above and Beneath the Skin. Texts by Douglas Dreishpoon, Eleanor Heartney, and Nancy Princenthal. Buffalo, New York: Albright-Knox Art Gallery, 2005.

Petah Coyne: Vermilion Fog. Texts by Ann Wilson Lloyd and Leslie Scalapino. New York: Charta Books and Galerie Lelong, 2008.

Princenthal, Nancy. *Petah Coyne: Fairy Tales.* Kilkenny, Ireland: The Butler Gallery, 1999.

Rubin, David S. *Petah Coyne.* Cleveland: Cleveland Center for Contemporary Art, 1992.

Sultan, Terrie and Przybilla, Carrie. *Petah Coyne: black/white/black.* Washington, D.C.: The Corcoran Gallery of Art, 1996

Books/Exhibition Catalogues/ Brochures

Albright-Knox Art Gallery, *On View: Petah Coyne* (brochure). Buffalo Fine Arts Academy, May/June 2006.

Anderson, Maxwell L. *Whitney Biennial 2000* (catalogue). New York: The Whitney Museum of American Art: pp. 78–9, 234.

—————. *Nomadic Visions.* North Dartmouth, Massachusetts: Southeastern Massachusetts University Art Gallery, 1988.

ARS 06: Sense of the Real (catalogue). Helsinki, Finland: Museum of Contemporary Art Kiasma.

Cameron, Dan, et al. *Artworks: The Progressive Collection.* New York: D.A.P./Distributed Art Publishers, Inc., 2007: pp. 128–9.

Collischan, Judy. "Petah Coyne." *Neuberger Museum of Art 1997 Biennial Exhibition of Public Art* (catalogue). Purchase, NY: Neuberger Museum, 1997.

Cross, Susan and Denise Markonish, eds. *Sol LeWitt: 100 Views.* North Adams, MA: MASS MoCA and New Haven: Yale University Press, 2009: p. 38.

Davies, Hugh M. *Lateral Thinking: Art of the 1990s* (catalogue). San Diego, CA: Museum of Contemporary Art, 2002: p. 119.

Davis, Keith F. *An American Century of Photography.* Kansas City: Hallmark Cards Inc., 1999: pp. 410, 465.

Ferrer, Elizabeth and Muffet Jones. *Terra Ferma, Land and Landscape in Art of the 1980s* (catalogue). New York: Columbia University, 1989.

Giovannotti, M. and J.B. Korotkin. *Neo Baroque!* (catalogue). Milano: Charta and Verona: Byblos Art Gallery, 2005.

Goldman, Judith and Leslie Scalapino, eds. *War and Peace: Vision and Text, Volume 4.* Oakland, CA: O Books, 2009: p. 1, back cover.

Goncharov, Kathleen. *The Forest: Politics, Poetics, and Practice* (catalogue). Durham, NC: Nasher Museum of Art at Duke University, 2005.

—————. *The New School Collects* (brochure). New York: New School for Social Research, 1991.

—————. *The Vera List Center for Art and Politics* (brochure). New York: The New School, 1996.

Hall-Duncan, Nancy and Peter C. Sutton. *Contemporary + Cutting Edge: Pleasures of Collecting, Part III* (catalogue). Greenwich, CT: Bruce Museum, 2007.

Heartney, Eleanor. *Post Modern Heretics: The Catholic Imagination in Contemporary Art.* New York: MidMarch Arts Press, 2004.

—————. *Art & Today.* New York: Phaidon Press Inc., 2008: pp. 208–10.

Heartney, Eleanor, Helaine Posner, Nancy Princenthal, and Sue Scott. *After the Revolution: Women Who Transformed Contemporary Art.* Munich, London, New York: Prestel, 2007: pp. 19, 184, 266.

Hess, Elizabeth and Mel Bochner. *In the Lineage of Eva Hesse* (catalogue). Ridgefield, CT: The Aldrich Museum of Contemporary Art, 1992.

Kitade, Chieko, ed. *Passion Complex: Selected Works from the Albright-Knox Art Gallery* (catalogue). Kanazawa, Japan: 21st Century Museum of Contemporary Art, 2007: pp. 32–5.

Kotik, Charlotta. *Untitled Installation* (brochure). Brooklyn: The Brooklyn Museum, 1989.

Landau, Ellen G., Marjorie Talalay, and Anselm Talalay. *25 Years, A Retrospective* (catalogue). Cleveland, OH: Cleveland Center for Contemporary Art, 1993.

Lippard, Lucy R. *The Pink Glass Swan.* New York: The New Press, 1995: pp. 8, 18.

McParland, Brenda. *The Glen Dimplex Artists Award 2000* (catalogue). Dublin, Ireland; Irish Museum of Modern Art: pp. 4–7.

Nine Contemporary Sculptors: Fellows of the Saint-Gaudens Memorial (brochure). New York: The UBS Art Gallery, 2005.

Philbrick, Harry. *Best of the Season* (catalogue). Ridgefield, CT: The Aldrich Museum of Contemporary Art, 1999: p. 5.

—————. *This Is Not Your Ordinary Art Catalogue, This Is Faith.* Ridgefield, CT: The Aldrich Museum of Contemporary Art, 2000: pp. 20, 42–3.

Princenthal, Nancy. *Other Choices, Other Voices* (brochure). East Islip, NY: Islip Art Museum, 1995.

Richards, Judith Olch, ed. *Inside the Studio: Two Decades of Talks with Artists in New York.* New York: Independent Curators International (ICI), 2004.

Rogers-Lafferty, Sarah. *Standing Ground: Sculpture by American Women* (catalogue). Cincinnati, OH: The Contemporary Arts Center, 1987.

Scalapino, Leslie. *Zither & Autobiography*. Middletown, CT: Wesleyan University Press, 2003: cover.

—————. *It's go in/quiet illumined grass/land*. Sausalito, CA: The Post-Apollo Press, 2002: p. 31.

—————. *The Public World/Syntactically Impermanence*. Hanover, NH: University Press of New England, 1999: cover.

Solnit, Rebecca. *As Eve Said to the Serpent: On Landscape, Gender, and Art*. Athens: The University of Georgia Press, 2001: p. 155.

Spretnak, Charlene. *Missing Mary: The Queen of Heaven and Her Re-emergence in the Modern Church*. New York: Palgrave Macmillan, 2004.

Sterling, Susan Fisher. *Steven Scott Collects* (brochure). Washington, DC: National Museum of Women in the Arts, 2005.

Tanaka, Hiroko. *Art Is Beautiful: Interviews with New York Artists*. Tokyo: Kawade Shobo Shinsha Publishing, 1990: pp. 135–40.

Van Wagner, Judy K. Collischan. *Line of Vision: Drawings by Contemporary Women*. New York: Hudson Hill Press, 1989: p. 40.

Weatherspoon Art Museum. *American Art 1960–Present: Selections from the Permanent Collection* (brochure). Greensboro, NC, 2004.

Weber, Bruce and Douglas Dreishpoon. *The Emerging Figure* (catalogue). West Palm Beach, FL: Norton Gallery of Art, 1989.

Whitney Museum of American Art. *American Visionaries: Selections from the Whitney Museum of American Art*. Introduction by Maxwell L. Anderson. New York, 2001: p. 80.

Yau, John. *A Contemporary View of Nature* (catalogue). Ridgefield, CT: The Aldrich Museum of Contemporary Art, 1986.

Magazine/Newspaper/Internet Articles

2010
Anania, Katie. "Desire: Blanton Museum of Art." *Artforum.com*, Critic's Pick, April 12, 2010.

Rosenberg, Karen. "Academy Gives Art Some Wiggle Room." *The New York Times*, February 18, 2010.

2009
Landi, Ann. "A New Creativity?" *ARTnews*, March 2009: pp. 86–9.

Straub, Kimberly. "Wax Poetic." *Vogue*, October 2009: p. 264.

2008
Smith, Roberta. "Chelsea: Art Chockablock with Encyclopedic Range." *The New York Times*, November 14, 2008: p. C28.

Siegel, Miranda. "Growth and Decay," *New York Magazine*, October 27, 2008: p. 90.

Halle, Howard. "Best in Sculpture." *Time Out New York*, October 23–29, 2008: p. 61.

2007
Suzuki, Hiroshi. "Passion Complex." *Chunichi News* (Kanazawa, Japan), August 1, 2007: pp. 18–19.

Nasher Museum of Art Presents New Acquisitions. *Artknowledgenews.com*, July 18, 2007.

2006
Lovelace, Carey. "Bringing It All Back Home, On Arlene Raven." *Artforum*, November 2006: pp. 61–2.

Gaasch, Cynnie. "Falling in Love, Petah Coyne at the Albright-Knox Gallery." *ArtVoice*, August 10–16, 2006: pp. 18–19.

Lange, Christy. "ARS06 Kiasma Helsinki, Finland." *Frieze*, Summer 2006.

MacAdam, Barbara. "In the Studio." *Art + Auction*, June 2006: pp. 40–6.

Holden, Wynter. "Death Becomes Her, Morbidly Fascinating SmoCA Show." *Phoenix New Times*, April 16, 2006: p. 52.

Genocchio, Benjamin. "Coming Attractions: From Coast to Coast, What to See: Buffalo." *The New York Times*, March 29, 2006.

Vogel, Carol. "Inside Art: Nasher's First Purchase." *The New York Times*, January 20, 2006.

Scottsdale Museum of Contemporary Art. "Petah Coyne: Above and Beneath the Surface." *www.smoca.org*.

Boettger, Suzaan. "Review of Exhibitions, New York: Petah Coyne at the Sculpture Center and Galerie Lelong." *Art in America*, January 2006: p. 118.

2005
Budick, Ariella. "Arts: The Best of Art 2005." *New York Newsday*, December 25, 2005.

Landi, Ann. "Artists and Their (Role) Models." *ARTnews*, December 2005: pp. 132–5.

Krantz, Claire Wolf. "Review Chicago: Petah Coyne." *Flash Art*, October 2005.

Glueck, Grace. "In Saint-Gaudens's Name, Found Objects and a Goose on a Noose." *The New York Times*, October 14, 2005.

Thorson, Alice. "Mischief or Melancholy: Two Sides of Petah Coyne." *The Kansas City Star*, October 9, 2005.

Thorson, Alice. "Friday; Petah Coyne at the Kemper." *The Kansas City Star*, September 11, 2005.

"Petah Coyne: Above and Beneath the Skin." *Artdaily.com*, September 18, 2005.

Castro, Jan Garden. "Petah Coyne: Baroque Transformations and Humor." *Sculpture*, September 2005: pp. 48–53.

Martegani, Micaela. "Petah Coyne." *Tema Celeste*, May/June 2005: pp. 74–75.

Wei, Lilly. "Up Now: Petah Coyne, The Sculpture Center." *ARTnews*, March 2005.

Harris, Jane. "Voice Choices: Art—A retrospective of wax-drenched, neo baroque sculpture." *The Village Voice*, February 16–22, 2005: p. 78.

Tsai, Eugenie. "Organic chemistry: Petah Coyne coverts funky materials—mud, hair, feathers, wax—into sculpture." *Time Out New York*, February 3–9, 2005: p. 59.

Artner, Alan G. "Coyne's Work Pushes Buttons." *Chicago Tribune*, Online Edition, May 19, 2005.

Hixson, Kathryn. "Girl, Abstracted." *Time Out Chicago*, May 12–19, 2005: p. 50.

Cohen, David, James Gardner, Walter Robinson, and Alexi Worth. "Review Panel #4 on Petah Coyne, Diana Thater, James Hyde and Cecily Brown." *The Review Panel* at the National Academy sponsored by Artcritical.com, New York, February 4, 2005.

Budick, Ariella. "Sculptures that embrace matters of life and death." *New York Newsday*, January 28, 2005.

Perreault, John. "Coyne of the Realm." *Artopia: John Perreault's Art Diary. Artsjournal.com*, January 24, 2005.

"Goings On About Town." *The New Yorker*, February 14–21, 2005.

"Petah Coyne: Above and Beneath the Skin." *Artdaily.com*, January 25, 2005.

Lloyd, Ann Wilson. "Petah Coyne's Waxworks: Petals on a Black Bough." *The New York Times*, January 16, 2005.

2004
Genocchio, Benjamin. "Art Previews: As Fall Beckons, Women Rule." *The New York Times*, September 5, 2004.

McQuaid, Cate. "Her Complex Art Proves Elusive Yet Satisfying." *The Boston Globe*, October 15, 2004.

Litt, Steven. "The Plain Dealer." *Cleveland.com*, March 28, 2004.

2003

Miokovic, Alex and Heidi Nickisher. "Narrating the Visceral Object." *City News* (Rochester, NY), December 3, 2003.

Rexer, Lyle. "Lee Bontecou Returns from Her Faraway Planet." *The New York Times*, October 5, 2003: sec. 2, p. 34.

Everett, Deborah. "The Next Chapter: Building the Sculpture Center." *Sculpture*, March 2003.

Schwalb, Susan. "Petah Coyne at MIT." *Art New England*, Feb/March 2003: p. 8.

2002

Lloyd, Ann Wilson. "Art Is a Necessity Among Techies, Too." *The New York Times*, December 15, 2002: sec. AR, pp. 50–1.

Tillman, Lynne. "To Find Words." *Blind Spot*, Issue 22.

MacAdam, Barbara A., Carly Berwick, and Andrea Crawford. "Speaking Volumes." *ARTnews*, November 2002: pp. 164–84.

Sheets, Hilarie M. "Artists Take On Detroit." *ARTnews*, Summer 2002: p. 182.

Tillman, Lynne. "Petah Coyne." *BOMB*, Summer 2002: pp. 24–31.

Castro, Jan Garden. "Controlled Passion, A Conversation with Petah Coyne." *Sculpture*, June 2002: pp. front cover, 22–9.

Sheets, Hilarie M. "The New New York." *ARTnews*, April 2002: p. 113.

Schwendener, Martha. "Petah Coyne." *Artforum*, February 2002: pp. 131–2.

Waxman, Lori. "Petah Coyne." *Tema Celeste*, January/February 2002: p. 79.

Wei, Lilly. "Petah Coyne." *ARTnews*, January 2002: p. 118.

Harris, Susan. "Petah Coyne at Galerie Lelong and Julie Saul." *Art in America*, January 2002: p. 102.

2001

Chomin, Linda Ann. "Visions of Detroit, Artists Take On the City." *Plymouth Observer* (Plymouth, MI), Nov. 11, 2001: sec. C, pp. 1, 4.

"Petah Coyne, Spring Snow." *Shout NY*, November 2001: p.10.

Spencer Museum of Art, "Striking new sculpture installed in 20th-Century Gallery." *www.cc.ukans.edu*, October 2001.

Bostwick, Alan. "Artist weaves strands of emotion into 'Fairy Tales.'" *The Tennessean* (Nashville), September 23, 2001: Arts & Leisure p. 16.

Sheets, Hilarie M. "The Mod Bod." *ARTnews*, June 2001: pp. 98–101.

Kuntz, Jane. "Petah Coyne's 'Fairy Tales' exhibit thru Jan. 28." *The Oakwood Register* (city), January 23, 2001: p. 3.

Wallach, Amei. "The Impenetrable that Leads to the Sublime." *The New York Times*, January 7, 2001: sec. AR, pp. 37, 41.

2000

Lloyd, Ann Wilson. "What I Saw at the Whitney." *Provincetown Arts*, vol. 15, Annual Issue 2000/01: pp. 132–3.

Vendrame, Simona. "Nature and the Solitary Self." *Tema Celeste*, Oct.–Dec. 2000: cover and pp. 52–3, 57–8.

Dunne, Aiden. "A Matchless Dimplex." *The Irish Times*, May 18, 2000, p. 14.

Wei, Lilly. "2000 Biennial Exhibition." *Artnews*, May 2000: p. 225.

Dunne, Aidan. "The Guide." *The Irish Times*, April 22, 2000.

Schwartz, Therese. "Nirvana Takes a Holiday: The Whitney Biennial in 2000." *Arts4All Newsletter: Memos from the World*, April 10, 2000.

"Glen Dimplex Artists Award." *Camera Austria: International*, April 2000.

Maxwell, Douglas F. "Biennial Lite." *Review*, April 1, 2000: p. 62.

Prose, Francine. "The Message Trumps the Medium at Whitney Biennial." *The Wall Street Journal*, March 30, 2000: sec. A, p. 28.

Newhall, Edith. "Biennial Angst." *New York*, March 27, 2000: pp. 77–80.

Levin, Kim. "Choices." *The Village Voice*, February 15, 2000: sec. Voice Choices, p. 92.

"AICA Selects Favorite Shows." *Art in America*, February 2000: p. 152.

Lloyd, Ann Wilson. "In a New Millennium Religion Shows Its Face." *The New York Times*, January 23, 2000: sec E, p. 43.

Morgan, Robert C. "Artists' Photographs: Straight and Sequential." *New York Arts Magazine*, January 2000.

1999

Murphy, Paula. "Petah Coyne." *Circa*, Winter 1999, pp. 41–2.

Vogel, Carol. "Flurries at the Whitney." *The New York Times*, December 31, 1999: sec. E, p. 42.

Dunne, Aidan. "Shortlist for artist's award is announced." *The Irish Times*, December 9, 1999: p. 2.

Vogel, Carol. "Choosing a Palette of Biennial Artists." *The New York Times*, December 8, 1999: sec. E, pp. 1, 5

Koplos, Janet. "Blankets of Darkness." *Art in America*, September 1999: pp. 116–9.

Walker, Dorothy. "Hair today, gone tomorrow." *The Times* (London), September 5, 1999: sec. D, pp. 24–5.

Dunne, Aidan. "Fairy tales and hairy tails." The Irish Times, August 18, 1999: sec. C, p. 11.

MacAdam, Barbara. "Canadian Beacon." *ARTnews*, April, 1999: pp. 72–4.

Heartney, Eleanor. "Blood, Sex, and Blasphemy." *New Art Examiner*, March 1999: p. 34–9.

Goodman, Jonathan. "Petah Coyne." *Sculpture*, March 1999: pp. 69–71.

1998

Tannen, Mary. "It's the Hair Stupid." *The New York Times*, November 1, 1998: sec. 6, pp. 6, 62.

Landi, Ann. "Beating the Post-Show Blues." *ARTnews*, November 1998: pp. 156–8.

MacAdam, Barbara A. "Petah Coyne." *ARTnews*, November 1998: pp. 165–6.

Levin, Kim. "Comb, Please." *The Village Voice*, October 20, 1998: p. 171.

"Goings On About Town." *The New Yorker*, October 12, 1998: pp. 18–19.

Schwendener, Martha. "Petah Coyne, 'Fairy Tales.'" *Time Out New York*, October 8–15, 1998: p. 62.

Dobrzynski, Judith H. "Steadily Weaving Toward Her Goal." *The New York Times*, October 6, 1998: sec. E, pp. 1, 3.

Levin, Kim. "Choices." *The Village Voice*, October 6, 1998: sec. Voice Choices, p. 89.

"Petah Coyne." *The New York Contemporary Art Report*, October 1998: pp. 58–9.

Johnson, Ken. "Petah Coyne 'Fairy Tales.'" *The New York Times*, September 18, 1998: sec. E, p. 35.

Maxwell, Douglas F. "Petah Coyne; 'Fairy Tales.'" *Review*, September 15, 1998: p. 11.

Newhall, Edith. "Galleries." *New York Magazine*, September 14, 1998: p. 126.

Findsen, Owen. "Wax Sculptures, the Buzz Around Arts Center." *The Cincinnati Enquirer*, April 12, 1998.

1997

Phillips, Patricia C. "'Dispatches'—1997 Biennial Exhibition of Public Art." *Sculpture*, December 1997: pp. 78–9.

Fox, Catherine. "Petah Coyne and Her Girls." *The Atlanta Journal Constitution*, May 9, 1997: sec. P, p. 18.

"Delicate Hanging Sculptures by Coyne Make Up High Museum Exhibition." *Americus Times Recorder*, May 8, 1997.

Zimmer, William. "Sprawling works, Thirteen Sculptors." *The New York Times*, May 4, 1997: sec. CN, p. 20.

Tully, Judd. "At the Edge." *Art and Auction*, May 1997: pp. 130–5.

Landi, Ann. "Site Specifics." *ARTnews*, April, 1997: pp. 116–8.

Fox, Catherine. "Coyne Looks Back at Dreams of Future." *The Atlanta Journal Constitution*, April 18, 1997: sec. P, p. 7.

"Hanging Sculptures by Artist Petah Coyne at High Museum." *Antiques and the Arts Weekly*, April 18, 1997.

1996
Smith, Roberta. "The World Through Women's Lenses." *The New York Times*, Dec. 13, 1996: sec. C, p. 28.

Newhall, Edith. "Photography — Monks on the Run." *New York Magazine*, Dec. 2, 1996: p. 150.

Gibson, David. "Petah Coyne." *NY Soho*, December 1996: p. 35.

Arning, Bill. "Petah Coyne — Photography." *Time Out New York*, November 28–December 5, 1996: p. 46.

Aletti, Vince. "Petah Coyne — Photography." *The Village Voice*, November 26, 1996; sec. Voice Choices, p. 9.

Hicks, Robert. "Getting the Camera Behind the Movement." *The Villager*, Nov. 13, 1996: p. 23.

Coyne, Petah. "Surface and Illusion, An Edge of Black." *Aperture*, Fall 1996: pp. 46–51.

Bennette, John. "Small Budgets, Large Ambitions." *ARTnews*, special edition, January 31, 1996: pp. 48–54.

MacAdam, Barbara. "Girl Talk." *ARTnews*, September 1996: Cover and pp. 104–7.

Huffstutter, P.J. "House of Wax." *The San Diego Union-Tribune*, June 20–25, 1996: sec. NC, p. 1.

1995
Damianovic, Maia. "Opinioni sul Fantastico, Immagini Senza Famiglia." *Tema Celeste*, no. 55, Numero Speciale dedicato al Fantastico Inverno, 1995: pp. 76–99.

Davenport, Kimberly. "Impossible Liberties, Contemporary Artists on the Life of Their Work Over Time." *Art Journal*, Summer 1995: pp. 40–52.

McQuaid, Cate. "The Ways of All Flesh, The List and Mass Art Examine the Body." *The Boston Phoenix*, February 3, 1995: sec.3, pp. 1–2.

Stapen, Nancy. "Feminine Dialogues: A Tempest from Oppenheim's Teacup." *The Boston Sunday Globe*, January 29, 1995.

Schwendewien, Jude. "Collectors: Barbara and Ira Sahlman." *Sculpture*, January/February 1995: pp. 18–19.

Bomb, Winter 1994/95: pp. 64–5.

1994
Ash, John. "Petah Coyne/Reviews." *Artforum*, October 1994: p. 103.

Garguilo, Thomas. "In the Lineage of Eva Hesse." *Art New England*, October/November 1994: pp. 46–7.

Bass, Ruth. "Petah Coyne." *ARTnews*, October 1994: p. 184.

"Gallery Reviews/Petah Coyne." *The New Yorker*, October 17, 1994: p. 29.

"New York Studio Events: Petah Coyne." *Independent Curators Incorporated Newsletter*, Fall 1994: p. 4.

Melrod, George. "New York, New York." *Sculpture*, July–August 1994: pp. 46–7.

Princenthal, Nancy. "Petah Coyne at Jack Shainman." *Art in America*, June 1994: p. 95.

Hess, Elizabeth. "Wax Poetic." *The Village Voice*, April 5, 1994: p. 94.

Levin, Kim. "Choices: The Garden of Sculptural Delights." *The Village Voice*, April 5, 1994: sec. Voice Choices, p. 73.

Wallach, Amei. "An Exuberant Celebration of Life." *New York Newsday*, April 1, 1994: sec. B, pp. 17, 21.

Larson, Kay. "Garden of Sculptural Delights." *New York Magazine*, March 28, 1994: p. 98.

Levin, Kim. "Choices." *The Village Voice*, March 23, 1994: sec. Voice Choices, p. 71.

Smith, Roberta. "Sculptors in the Shadow of a Minimalist Master." *The New York Times*, March 18, 1994: sec. C, p. 21.

1993
Sachs, Sid. "Petah Coyne." *The New Art Examiner*, December 1993: p. 34.

Weschler, Lawrence. "Portfolio, Slight Modifications." *The New Yorker*, July 12, 1993: pp. 59–65.

1992
Aletti, Vince. "Choices." *The Village Voice*, December 29, 1992: sec. Voice Choices, pp. 73–4.

Boettger, Suzaan. "Dirt Works." *Sculpture*, November/December 1992: pp. 38–43.

Levin, Kim. "Choices." *The Village Voice*, August 4, 1992: sec. Voice Choices, p. 71.

Acocella, Joan. "Choices." *The Village Voice*, May 26, 1992: sec. Voice Choices, p. 84.

Chico, Beth. "Petah Coyne/Cleveland Center for Contemporary Art." *Dialogue*, May/June 1992: pp. 1, 3.

Cullinan, Helen. "Alien Hulks of Brooding Human Emotion." *The Cleveland Plain Dealer*, March 15, 1992.

1991
Spring, Justin. "Petah Coyne." *Artforum*, December 1991: p. 104.

Taplin, Robert. "Petah Coyne at Jack Shainman and Diane Brown." *Art in America*, December 1991: pp. 108–9.

Cyphers, Peggy. "New York in Review/Petah Coyne." *Arts*, December 1991: p. 79.

Drieshpoon, Douglas. "Petah Coyne." *ARTnews*, December 1991: p. 124.

Schwartzman, Allan. "Petah Coyne." *The New Yorker*, October 7, 1991: pp. 14–15.

Kimmelman, Michael. "Art in Review." *The New York Times*, October 4, 1991: sec. C, p. 24.

Newhall, Edith. "Fall Preview." *New York Magazine*, September 23, 1991: pp. 56–64.

Harrison, Helen A. "The Natural World and Its Mysteries." *The New York Times* (Long Island Edition), August 11, 1991: p. 13.

Smith, Roberta. "On Long Island, Photos, Portraits, Pollock and Stereotyping." *The New York Times*, August 9, 1991: sec. C, p. 22.

Baker, Kenneth. "Awards Show Triggers Censorship Memories." *San Francisco Chronicle*, July 21, 1991.

Sweeney, Louise. "Controversial Show Salutes Top 10 in the Visual Arts." *The Christian Science Monitor*, July 19, 1991: p. 10.

Gibson, Eric. "This Is What Wins Awards?" *Insight*, July 8, 1991: pp. 40–1.

"Nine Abstract Artists at Heckscher." *The Long Islander*, June 27, 1991: p. 2.

Gibson, Eric. "Awards Based on Politics Slander Two Deserving Artists." *The Washington Times*, June 20, 1991: sec. F, pp. 1, 5.

Lewis, Jo Ann. "Tantalizing Reflections at the Hirshhorn, the Power of 10 Artists." *The Washington Post*, June 12, 1991: sec. F, pp. 1, 9.

Wye, Pamela. "This, This, This Body: The Sculpture of Petah Coyne." *Sulfur*, Spring 1991: pp. 53–62.

1990
Solnit, Rebecca. "Dirt." *Art Issues*, December 1990/January 1991: pp. 30–35.

Avgikos, Jan. "The (Un) Making of Nature, Whitney Museum Downtown." *Artforum*, November, 1990: pp. 165–6.

LePage, Jocelyne. "Art Contemporain 90: L'Art-Spectacle de la Jeune Generation." *La Presse* (Montreal), September 29, 1990: sec. D, p. 13.

Loughery, John. "Lines of Vision: Drawing by Contemporary Women." *Women's Art Journal*, Fall 1990/ Winter 1991.

Levin, Kim. "Choices." *The Village Voice*, July 31, 1990: sec. Voice Choices, p. 101.

Be-Haim, Tsipi. "Awakening the Brooklyn." *Sculpture*, May/ June 1990: pp. 68–73.

Holst, Lise. "Petah Coyne at Jack Shainman." *Art in America*, February 1990: pp. 174-5.

Mahoney, Robert. "Petah Coyne/ Jack Shainman/ Brooklyn Museum." *Sculpture*, January/February 1990: pp. 68–9.

Holst, Lise. "Terra Firma: Land and Landscape in Art of the 1980s." *ARTnews*, January 1990: pp. 169–70.

1989
Phillips, Patricia C. "Petah Coyne/ Brooklyn Museum, Jack Shainman Gallery." *Artforum*, December 1989: p. 137.

Dreishpoon, Douglas. "Petah Coyne." *Arts Magazine*, December 1989: p. 82.

Grimes, Nancy. "Petah Coyne/ Jack Shainman." *ARTnews*, November 1989: p. 161-2.

Semel, Nava. "The Forest and the Grass/Petah Coyne." *Studio Art Magazine* (Israel), November 1989: p. 46.

Kimmelman, Michael. "Petah Coyne/ Brooklyn Museum." *The New York Times*, October 6, 1989: sec. C, p. 27.

Amann, Gloria. "Petah Coyne/Jack Shainman Gallery." *Cover Magazine*, October 1989: p. 14.

Raven, Arlene. "Black Madonna." *The Village Voice*, September 26, 1989: p. 94.

Schwartzman, Allan. "Art." *The New Yorker*, September 26, 1989: p. 11.

Levin, Kim. "Choices." *The Village Voice*, September 26, 1989: sec. Voice Choices, p. 52.

Brenson, Michael. "Petah Coyne." *The New York Times*, September 8, 1989: sec. C, p. 22.

Grimes, Nancy. "Kindred Spirits: Metaphysical Insights of Seven Sculptors." *New Art Examiner*, March 1989: p. 52.

1988
Mahoney, Robert. "Long Island University/C.W. Post." *Arts Magazine*, November 1988: p. 117.

————. "David and Goliath." *Arts Magazine*, October 1988: p. 102.

Gibson, Eric. "Nature and Sculpture, A New Subjectivity Takes Root." *Sculpture*, September/October, 1988: pp. 28–31.

Levin, Kim. "Choices." *The Village Voice*, July 19, 1988: sec. Voice Choices, p. 42.

Heartney, Eleanor. "Elements: Five Installations." *ARTnews*, April 1988: p. 56.

Levin, Kim. "Choices." *The Village Voice*, March 22, 1988: sec. Voice Choices, p. 50.

Shicho-Shaj. "Elements, Five Installations." *The Geijutsu-Shinsho* (Tokyo), April 1988: p. 56.

Levin, Kim. "Artwalk." *The Village Voice*, January 5, 1988: p. 84.

Bartelik, Marek. "Vidziane Z Manhattanu." *Prezglad Polske* (Poland), January 1–3, 1988.

1987
Phillips, Patricia. "Petah Coyne, Sculpture Center." *Flash Art*, November/December 1987: pp. 107–8.

Brenson, Michael. "Maverick Sculptor Makes Good." *The New York Times Magzine*, November 1, 1987: pp. 84, 88, 90, 92–3.

Levin, Kim. "Choices." *The Village Voice*, October 6, 1987: sec. Voice Choices, p. 44.

————. "Choices." *The Village Voice*, September 29, 1987: sec. Voice Choices, p. 46.

Brenson, Michael. "Critics' Choice." *The New York Times*, September 13, 1987: The Guide, p. 2.

————. "Season Preview, A Selective Guide." *The New York Times Magazine*, August 30, 1987: pp. 111–3.

————. "City as Sculptural Garden: Seeing the New and Daring." *The New York Times*, July 17, 1987: sec. C, pp. 1, 24.

Zimmer, William. "Sculpture Carefully Created for a Site." *The New York Times*, June 28, 1987: p. 24.

Brenson, Michael. "Petah Coyne." *The New York Times*, May 22, 1987: sec. C, p. 24.

Gonzales, Shirley. "Sydney Blum, Petah Coyne, Beverly Fishman." *The New Haven Register*, May 3, 1987: sec. 3, p. D.

Levin, Kim. "Voice Centerfold." *The Village Voice*, March 17, 1987: p. 72.

Brenson, Michael. "Critics' Choice." *The New York Times*, January 18, 1987: The Guide, p. 2.

1986
Brenson, Michael. "Sculpture Breaks the Mold of Minimalism." *The New York Times*, November 23, 1986: sec. 2, pp. 1, 33.

Schwabsky, Barry. "Sydney Blum/ Petah Coyne/Beverly Fishman." *Arts Magazine*, November 1986: p. 120.

"Fishes and Habits." *Stroll, The Magazine of Outdoor Art and Street Culture*, November/December/ January 1986: p. 15.

Brenson, Michael. "DiSuvero's Drama of a Sculpture Park Grows in Queens." *The New York Times*, October 12, 1986: sec. 2, pp. 31–2.

Zimmer, William. "Sydney Blum, Petah Coyne, Beverly Fishman." *The New York Times*, September 19, 1986: sec. C, p. 25.

Brenson, Michael. "A Transient Art Form with Staying Power." *The New York Times*, January 10, 1986: sec. 2, pp. 33, 34

————. "A Bountiful Season In Outdoor Sculpture Reveals Glimmers of a New Sensibility." *The New York Times*, July 18, 1986: sec C, pp. 1, 20.

Long, Robert. "Review." *The Southampton Press*, June 19, 1986.

Brenson, Michael. "Review." *The New York Times*, June 13, 1986.

Stapen, Nancy. "Nature Exhibit Needs a Focus." *The Boston Herald*, February 14, 1986: Weekend, p. 66.

1985
Lewis, Pamela. "Bayou Show." *The Houston Post*, March 23, 1985: sec. G, pp. 1, 2.

1984
Schwarze, Richard F. "Arts/Petah Coyne." *The Journal Herald*, September 1, 1986: p. 23.

1983
Larson, Kay. "On the Beach." *New York Magazine*, September 5, 1986: pp. 52–3.

Glueck, Grace. "Engaging Experiments Transform a Sandy Site." *The New York Times*, July 31, 1986: sec. H, pp. 25, 6.

Acknowledgements

A project doesn't go forward without the generous support of patrons and foundations. Toby Lewis understands and advocates the power of art. She "believes," and her firm belief IS contagious. Very early in my career she gave me the great opportunity to make a site-specific work for the Progressive Corporation in Ohio. She has generously supported my work since, and I'm thrilled that she was the first patron to support this exhibition. When the Elizabeth A. Sackler Center for Feminist Art opened at the Brooklyn Museum, I was in awe of its all-encompassing vision. The woman behind that vision is even more awe-inspiring! When I was a young artist, Barbara Lee's name was revered as one of the few patrons who supported women, and she did this when it was "uncool." Now, thank goodness, many have followed her example and I'm grateful for her support. I'm especially honored that these three exceptional women have come together to support my show at MASS MoCA.

There could never be a thank-you bright enough, or bold enough, to express my deep appreciation to the organizations and individuals who have made this exhibition possible: the Massachusetts Cultural Council, Dennis Braddock and Janice Niemi, Carol and William Browne, Zoe and Joel Dictrow, Pamela and Robert Goergen (in whose garden *Scalapino Nu Shu* was originally conceived!), Jane and Leonard Korman, Anita Laudone (a very special artist in her own right) and Colin Harley, Kari McCabe and Nate McBride, Kate and Hans Morris, Martha and Sam Peterson, Elizabeth Ryan and the Stone Ridge Orchard.

Two good friends whose support I cherish more than ever are Linda and Ronald Daitz. Both have consistently provided careful and thoughtful advice and counsel through the years.

There are few people whose vision I trust or admire more than Nate McBride's. As an architect, he understands space like no other, and he generously gave of his talents in helping to shape the space and exhibition at MASS MoCA.

Elizabeth Ryan of Stone Ridge Orchard loves and understands both nature and art equally, a rarity these days. She raises her trees as her art form—her sculpture—and she donated the most beautiful of all to be the centerpiece of this exhibition.

MASS MoCA blew onto the scene eleven years ago, but would not have withstood the test of time had it not been for the dedication and determination of founder and director Joseph Thompson. He has developed a hard-working and talented group of people whose sole purpose is to exhibit innovative forms in the visual arts and to provide an unmatched home for the performance arts. When curator Denise Markonish visited my studio in May 2009, I was amazed by our common love for literature and mutual and deep admiration of birds. Denise had the courage and the vision to identify "now" as the perfect moment to bring this work to MASS MoCA. I am grateful for her invitation to mount the exhibition and for her curatorial partnership throughout this last action-packed year. I am also grateful to Denise for her vision of a publication that was not "just another catalogue" and for her belief in the project at every juncture. She guided the designers, Dan McKinley and Liz Plahn, who skillfully understood that my work needed simplicity and quiet to surround its very being, allowing it to breathe on the page.

Dante Birch is a true team player, and his gentlemanly qualities, something so rarely experienced these days, were much appreciated. His ability to carefully organize projects on a scale and magnitude that would daunt many, as well as his thoughtful manner, only add to his charm. Richard Criddle is amazing. His brilliant and innovative thinking was a wonder to watch. He made shipping and installation a joy and the whole installation experience fun, since everything fit by a good half inch! The MASS MoCA crew was stellar: Jason Wilcox, John Carli, Kim Faler, Ryan McCabe, Cody Johnson, Alton "Skip" Wright Jr., and George Canales. There are many others whose countless hours of hard work and great attitudes always raised a smile, and they must be acknowledged: Jennifer Trainer Thompson, Art McConnell, Deborah M. Rothschild, and Calley Morrison, to name just a few.

Galerie Lelong has gone beyond the normal role of a gallery in all its contributions to the show. The entire staff worked on almost every aspect of this exhibition and ALSO three similar-sized exhibitions and accompanying catalogues within the past five years—enough work to derail the mightiest. My admiration and respect for them all could not be greater. Mary

Sabbatino, the gallery's vice president, is passionate about what she does, and is dedicated to ensuring that each and every artist has exactly what they need to make their work — well, what more could any artist ask for in a dealer? She asks her staff to mirror her commitment to artists, and they have all done so with true generosity.

Mark Hughes, Galerie Lelong's director, uses his formidable organizational skills, keen insight, and sense of humor to keep us all on track. From our first site visit to MASS MoCA, Lindsay Macdonald Danckwerth, associate director, helped me to coordinate all aspects of the exhibition and catalogue with kindness, thoughtfulness, grace, and precision. Her contribution has been invaluable and inestimable. Wade Miller, registrar, worked with my studio to organize the exhibition lists, safeguard the works, and to help us solve many complex problems of packing and crating. Hannah Adkins, archivist, and Amanda Salvaggio, gallery assistant, gathered all photographic and archival material for the installation and catalogue with accuracy, good humor, and good will. Doug Breismeister, preparator, assisted my studio and the gallery with diligence and care. Without the collective hard work, innovative planning, and ongoing support of these seven people, these three large exhibitions — and especially my show at MASS MoCA — simply would not have happened.

Long a huge fan of Rebecca Solnit's exceptional and prescient writing, I am honored to have worked with her on this catalogue. The esteemed writer A.M. Homes created a new piece of fiction for the publication, inspired in part by North Adams, a place she summered as a child.

My assistants say that it takes an army to create a Petah Coyne exhibition. I am blessed to work with these incredible individuals, many of whom are artists themselves. Each of my assistants gave of their vision — something that provides incalculable value. They also give amply of their time, often putting their own work aside. This is a great gift for an artist, to have the support and hands of other fellow artists. In particular, I want to recognize Steven Millar, who is head of my studio. An accomplished artist and a technical wizard, Steven has put his extraordinary skills at the service of my newest work, *Scalapino Nu Shu*. This work would absolutely not exist if it were not for him. Lucienne Pereira has true generosity of spirit as well, only matched by her physical strength, gentle humor, and terrific energy. Monique Luchetti, also a superb artist, is the glue that holds our studio together, especially for documentation and archiving. Thank you to Alison Stigora and Jes Gettler for their enthusiasm, focus, and willingness to take on any task necessary to get the job done. Special thanks to Elisabeth Bernstein, Melody Litwin, Elizabeth Ferry, Erin Kennedy, Trevor Reese, Harold Tamara, Dego, Liz Levin, Amanda Katz, Lauren Edwards, Caitie Gibbons, Anastasiya Gutnik, Deirdre Nolan, Sarah Christian, and Courtney Coolbaugh all of whom contributed their skills during this exhibition's genesis. And very special thanks to Nancy Jimenez, who helped on numerous occasions when the studio required her proven design skills and advice on layout. She never failed to give invaluable insight and assistance.

The task to complete the works for MASS MoCA was much too complicated and difficult, and I feared I would not finish them on time. In order to do so, I reached out to personal friends and other artists who, without hesitation, dropped what they were doing and came to another artist's SOS call. This made me realize, yet again, what NYC's art community is all about. Very special thanks to Gary Petersen, Analia Segal, Judith Klinger, and Kathy Grove.

Special thanks to Beatrice Coyne, who for ten years, along with her partner, Robert Manning Brent Jr., has provided both physical and compassionate care for my parents. I will forever be in their debt for such unheralded assistance.

Finally, they say each person gets one major gift in their life; mine happens to be my husband, Lamar Hall. He is the single most important thing that ever happened to me. Thank you, Lamar.

— *Petah Coyne*

This book is dedicated to Leslie Scalapino.
(1944–2010)

I would like to acknowledge the following for their help and support throughout the process of mounting *Petah Coyne: Everything That Rises Must Converge*. Petah has dedicated the last year to working on this exhibition and making sure every last detail is just right, all the while producing two stunning new works for the show (and sharing reading lists with me); the staff of Galerie Lelong, who went above and beyond the call of duty, especially Mary Sabbatino, Lindsay MacDonald Danckwerth, Wade Miller, and Hannah Adkins; all those working both at Petah's studio and on-site at MASS MoCA: Steven Millar, Lucienne Pereira, Monique Luchetti, Jes Gettler, and Alison Stigora; and Nate McBride, for his insights on Petah's work, space and color.

Thank you to the funders of the exhibition and catalogue: The Toby D. Lewis Philanthropic Fund of the Jewish Community Federation of Cleveland, the Elizabeth A. Sackler Museum Educational Trust, Galerie Lelong, McBride & Associates Architects, and the Massachusetts Cultural Council. Additional support came from Dennis Braddock and Janice Niemi, Carol and William Browne, Linda and Ronald F. Daitz, Pamela and Robert Goergen, Jane and Leonard Korman, Anita Laudone and Colin Harley, the Barbara Lee Family Foundation, Kari McCabe and Nate McBride, Kate and Hans Morris, Sam and Martha Peterson, Elizabeth Ryan, and Stone Ridge Orchard. And thanks to Joseph Baio, Tom and Leslie Maheras, and Weil, Gotshal & Manges LLP, who loaned work to the exhibition.

At MASS MoCA, I would like to thank Joe Thompson for his support and enthusiasm for this project, and MASS MoCA's installation crew, without whom nothing would happen: Richard Criddle, Jason Wilcox, John Carli, Kim Faler, and Ryan McCabe, with additional help from Alton "Skip" Wright, Jr. and George Canales. Art McConnell and the maintenance crew transformed the space to make it "NASA clean." Thanks to Dante Birch who helped with all aspects of loan forms, contracts and scheduling, etc., Calley Morrison—who always jumps in to help with a smile—and Kacey Light, Shannon Toye, Emily Carr, and Oliver Wunsch. Thank you to Meghan Robertson for organizing all of our housing needs, and to Jennifer Trainer Thompson, Laurie Werner, and Daryn Glassbrook for their help with fund-raising, donor events, and beyond.

This catalogue would not have been possible without Yale University Press—especially Patricia Fidler and Lindsay Toland—graphic designer Dan McKinley, Liz Plahn, copy editors Jane Calverley and Paulette Wein, photographer Art Evans, Brad Gooch, Jennifer Belt at Art Resource, New York, and Jin Auh and Jacqueline Ko at the Wylie Agency, New York. I also want to thank the authors whose writings illuminate this book and push it beyond a normal exhibition catalogue. As voracious readers, Petah and I feel honored to be in the company of A.M. Homes and Rebecca Solnit.

I would also like to thank Jay Lees for his support through much of this project and for keeping all those things in his basement for me; it's nice to know they are there (thud).

—*Denise Markonish*